IMAGES
of America

OAKLAND
FIRE DEPARTMENT

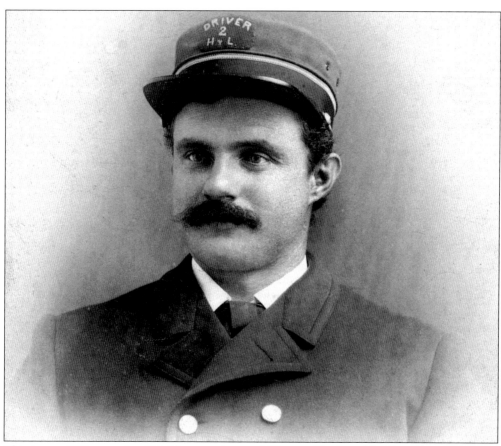

This is a c. 1901 portrait of J.J. Hogarty, driver of Clinton Hook and Ladder Company No. 2, who was appointed to the Oakland Fire Department on November 15, 1892. (Courtesy of Ed Clausen.)

THE FIREMAN

The general public as a rule do not give a thought about the duties, dangers, and risks that are the every-day lot of our modern fire-fighters, but at the clanging of the gong, the rich man, poor man, clerk, and in fact everybody within hearing drops business and work and rushes toward the point of alarm, the apparatus goes clashing by in a shower of sparks, the firemen hastily donning their helmets and rubber coats. It may prove a false alarm, and again it may be that they are going into action, where one or more of them may be killed or crippled for life.

Do they hesitate? No! Each company vies with the other to arrive first at the conflagration, each man rushes to his post of duty, each tries to be first to enter the burning building, each man tries to show his contempt of danger, and each ties to out-do his brother man in deeds of heroism. Such are the every-day occurrences in the life of our greatest of all protectors, the blue-shirted fireman.

(Excerpted from the *Oakland Fire Department Illustrated*, published in March 1901 to benefit the OFD Relief Fund.)

ON THE COVER: Downtown companies of the Oakland Fire Department fight a multi-alarm fire in a warehouse on Fifth and Cypress Streets in May 1968. (Courtesy of the Oakland Fire Department.)

IMAGES of America
OAKLAND FIRE DEPARTMENT

Captain Geoffrey Hunter

Copyright © 2005 by Captain Geoffrey Hunter.
ISBN 0-7385-2968-0

Published by Arcadia Publishing
Charleston SC, Chicago IL, Portsmouth NH, San Francisco CA

Printed in Great Britain

Library of Congress Catalog Card Number:

For all general information contact Arcadia Publishing at:
Telephone 843-853-2070
Fax 843-853-0044
E-mail sales@arcadiapublishing.com
For customer service and orders:
Toll-Free 1-888-313-2665

Visit us on the internet at http://www.arcadiapublishing.com

For Kate

"I can think of no more stirring symbol of man's humanity to man than a fire engine."

—Kurt Vonnegut

Contents

Acknowledgments		6
Introduction		7
1.	Origins and Organizations	9
2.	The Horse-Drawn Days (1869–1922)	17
3.	Motorization (1908–1922)	29
4.	Modernization (1922–1955)	39
5.	The Fireboat (1948–2003)	75
6.	The Oakland Fire Department Evolves (1956–1985)	85
7.	Modern Disasters	103
8.	The Oakland Fire Department Today	109
9.	Serving with Honor	117

ACKNOWLEDGMENTS

The author would like to thank Capt. Dave Hector for his untiring assistance putting this project together. This book would not have been possible without his efforts and those of Lt. Ed Clausen (OFD, retired), Battalion Chief Neil Honeycutt (OFD, retired), Lt. Clancy Crum (OFD, deceased), and Lt. Rich Schneider (Seattle Fire Department, retired) who have selflessly collected, preserved, and protected so much of the written and photographic history of the Oakland Fire Department.

Many thanks to John Esquivel of the *Oakland Tribune*, who allowed access to a treasure trove of images in their archives that hadn't seen the light of day in many years. Thank you to Nick Lammers, also of the *Oakland Tribune*, for allowing the use of his photograph. Thanks also go out to fire buffs Frank Wong (whom the OFD nicknamed "Photo 1") and Danny Barlogio. These two men have selflessly given so much of their time to capture the history of the OFD in photographs. Thank you both. Although Frank is now a "retired fire buff," Danny is continuing Frank's legacy. Nice going, Danny!

The author will donate a portion of the proceeds from the sale of this book to Oakland Firefighters' Random Acts of Kindness, a non-profit group made up of dedicated members of the OFD who are committed to creating a positive difference in the lives of individuals through random acts of kindness.

INTRODUCTION

This is the story of the brave men and women of the Oakland Fire Department who have courageously protected the lives and property of the citizens they have served since March 13, 1869. Their story began 135 years ago with the formation of Phoenix Engine Company No. 1, Washington Engine Company No. 2, and Relief Hook and Ladder Company. These early Oakland companies were pulled to emergencies by gallant fire horses with names like Bat and Pete. These horses were as much firefighters in their own right as the rugged men of Oakland who extinguished blazes with leather hoses and brass nozzles.

From this humble beginning, the Oakland Fire Department has grown almost tenfold and serves a population of over 400,000 citizens. Gone are the faithful fire horses and in their place are massive fire engines and fire trucks. The modern Oakland Fire Department is as diverse in its operations as the community that it serves. Today Oakland's firefighters are trained in highly technical specialties such as advanced life support, hazardous materials, heavy rescue, confined-space rescue, and airport rescue firefighting. The department has faced difficult trials throughout its long history and has always prevailed. The Oakland Fire Department will continue to evolve to meet new challenges and combat the many faceless dangers that continually threaten the citizens of Oakland.

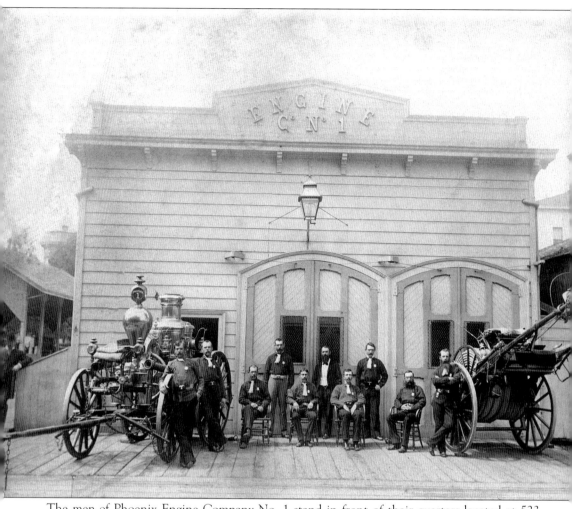

The men of Phoenix Engine Company No. 1 stand in front of their quarters located at 523 Fifteenth Street in this c. 1885 photograph. Their new 1885 Ahrens steamer was capable of delivering 550 gpm (gallons per minute) while the hose cart, a two-wheeled 1878 Hayes-Kimball, carried 650 feet of fire hose. (Courtesy of the Oakland Fire Department.)

One
ORIGINS AND ORGANIZATION

The Oakland Fire Department began with the volunteer fire companies that dotted the eastern shore of San Francisco Bay in the mid-1800s. The first attempt to organize a fire department in Oakland was made in 1853 with the formation of three hand-drawn engine companies—Empire Engine, Washington Engine, and Oakland Hook and Ladder—and the election of John W. Scott as chief engineer. These early companies were located in the vicinity of Fifth and Washington Streets. After two years, the city council disbanded the companies because of their inefficiency, and their equipment and property were distributed to other volunteer companies being formed, such as the Hancock Fire Brigade, a military organization. During this period, the Oakland City Council attempted to reduce fire losses by restricting the scope of volunteer fire brigade response to lots along Broadway and prohibiting the erection of wood-frame buildings in this area.

Veterans under the direction of John W. Scott, former volunteer chief engineer, at that point a colonel, formed the present-day Oakland Fire Department on March 13, 1869. Phoenix Engine Company No. 1 was located on Fifteenth Street in a one-story frame building, believed to have been built for the volunteer department in 1854 and later remodeled for the OFD. Washington Engine Company No. 2 and Relief Hook and Ladder Company were located in temporary quarters until 1870, when the firehouse at Fifth and Washington Streets was completed. Although this two-story frame building was, ironically, later destroyed by a fire, the efforts of the valiant firefighters saved all the equipment and horses. All early OFD records, unfortunately, were destroyed in the blaze.

James Hill, Oakland's first professional department chief, was appointed to his post on February 4, 1878, by the city council. A veteran of the New York Fire Department and chief of the Cleveland Fire Department for 17 years, Chief Hill brought with him a level of expertise the OFD desperately needed. His five-year administration would lay the foundation for what would become one of the most respected fire departments in the country.

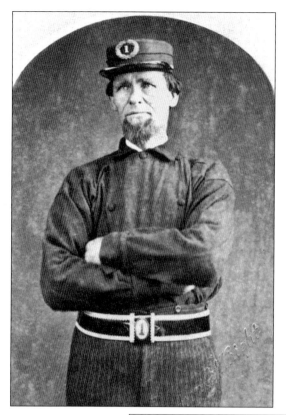

A stoic Frederick Schimmelfennig (1827–1902) had his picture taken in the 1880s wearing his dress uniform as a member of Phoenix Engine Company No. 1, where he served as an Extraman (Oakland's volunteer firemen). Extramen served the OFD until 1910, when the department became fully paid. Many of Oakland's first firemen were immigrants from Ireland, Italy, and, in the case of Schimmelfennig, Germany. (Courtesy of the Oakland Library.)

The crew of Engine Company No. 25 helps to guide the OFD's Fire Bell into place in front of their quarters on Butters Drive in the early 1950s. The bell, manufactured in 1877 by the McShane Foundry in Baltimore, Maryland, was used for many years to alert Extramen to report for duty in the event of an emergency. (Courtesy of the Oakland Fire Department.)

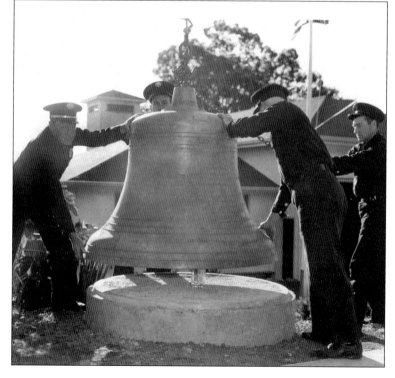

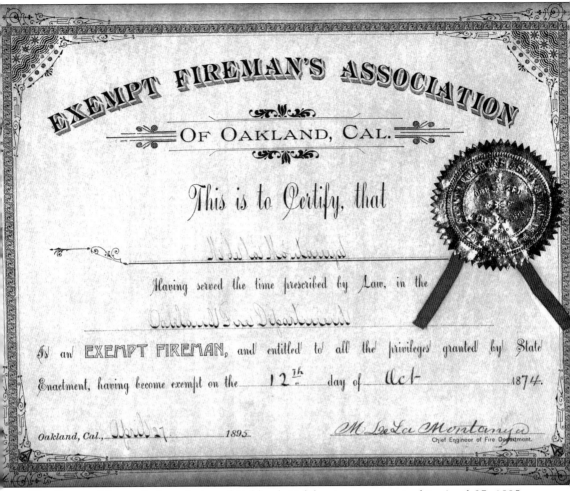

The Exempt Fireman's Association of Oakland, California, was organized in April 27, 1895, and was made up of professional Oakland firemen who attained 20 years of service. This certificate belonged to Matthew de la Montoya, Oakland's fourth chief of department, who joined the OFD on October 12, 1874, and retired on April 27, 1895. (Courtesy of the Oakland Fire Department.)

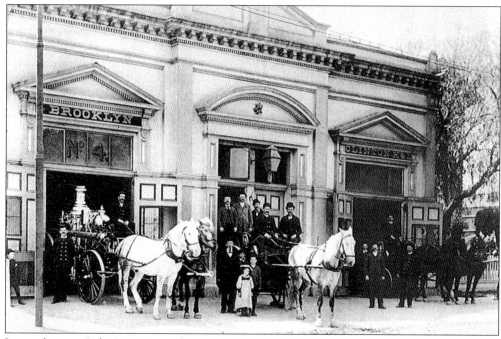

Located across Lake Merritt, to the east of Oakland, was Brooklyn Township. Brooklyn was annexed by the City of Oakland in 1872. For financial reasons, the Brooklyn Township Volunteer Fire Department remained separate from the OFD until 1877. Shown here are the members of Brooklyn Engine Company No. 4, Hose Company No. 2, and Clinton Hook and Ladder Company No. 2. (Courtesy of the Oakland Fire Department.)

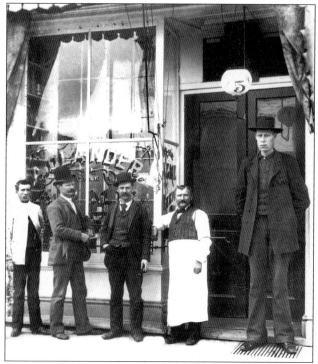

Standing over eight feet tall, Joe Sullivan was known as "the Brooklyn Giant." He served for many years as an Extraman Driver for the Brooklyn VFD. When he died unexpectedly in his sleep, his fellow firemen were forced to lower Sullivan's immense body out of the Brooklyn firehouse's second-story window. (Courtesy of the Oakland Library.)

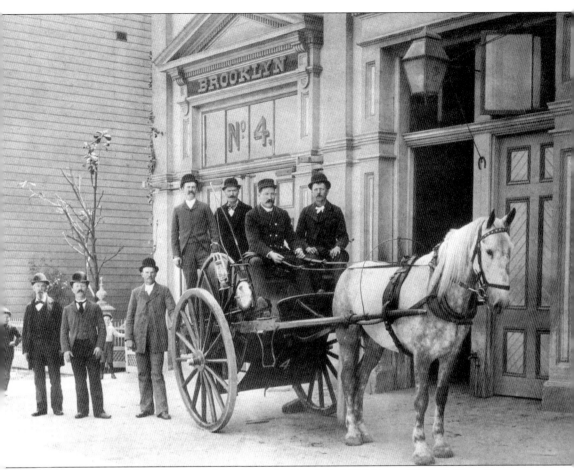

The Extramen of Hose Company No. 2 stand with their 1880 Hayes-Kimball Hose Cart, c. 1885. Hose carts were essential to early ground operations, as the steamers carried only short sections of hard suction hose used to connect to fire hydrants. The hose cart provided a smaller diameter hose that was used to attack the fire. (Courtesy of the Oakland Library.)

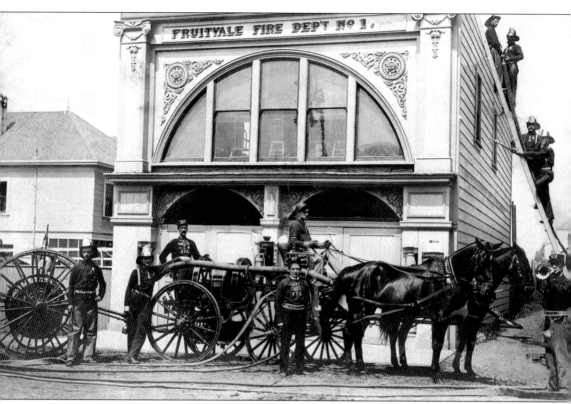

The members of Fruitvale Volunteer Fire Department (FVVFD) pose with their brand-new Waterous Steamer and Hose Cart in front of their firehouse located at 1211 Thirty-third Avenue, c. 1900. The FVVFD had two firehouses, No. 1 pictured here, and No. 2 located at 3461 Champion Avenue, which served the Dimond District. These two companies were incorporated into the OFD as Engine Company Nos. 13 and 14 in 1909, when the City of Oakland annexed the town of Fruivale. (Courtesy of the Oakland Fire Department.)

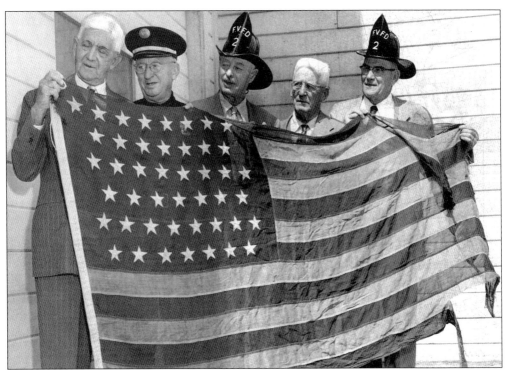

This 1956 photo shows, from left to right, W.B. Brookes, Capt. Arthur Decker, O.R. Hermann, H.L. Moyce, and Herbert Walden. The 45-starred American flag they are holding is the very flag that flew over Engine Company No. 14's quarters when it opened in 1909. These five men were all Fruivale volunteers and later Oakland firemen. (Courtesy of the *Oakland Tribune*.)

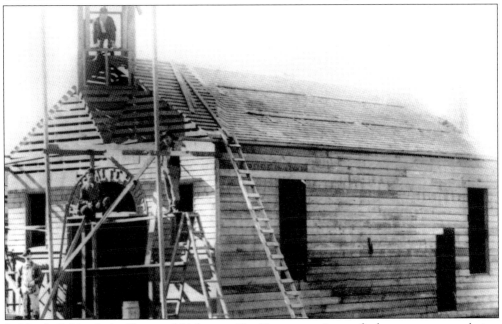

In North Oakland, the Temescal Volunteer Fire Department's new firehouse nears completion in this early photograph. (Courtesy of the Oakland Fire Department.)

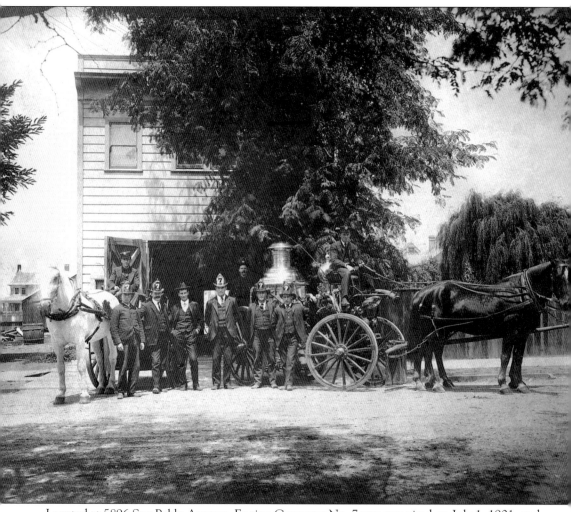

Located at 5896 San Pablo Avenue, Engine Company No. 7 was organized on July 1, 1901, and served North Oakland's Golden Gate district until July 1, 1979, when it was disbanded due to budget cuts. The company reopened in 1999 in a new location in the Oakland hills. (Courtesy of the Oakland Fire Department.)

Two
THE HORSE-DRAWN DAYS (1869–1922)

The image of a team of magnificent fire horses pulling a steamer belching black smoke and embers, with firemen holding on for dear life as it races to a working fire, is one that—sadly for us—lives only in photographs. These images, frozen in time, take us back to an era of wooden ladders, leather hoses, and iron men. The horse-drawn days of the Oakland Fire Department lasted from 1869 until 1922.

For over 50 years, horses faithfully pulled a variety of fire apparatus, including steamers, hose carts, ladder trucks, and chiefs' buggies for the Oakland Fire Department.

The life of a fire horse in Oakland was hard, even though the horses were accorded the best care given to any animal of the time. They were confined to stalls located next to their apparatus most of the day. Department rules required that the horses be exercised each day, weather permitting. Firefighters fed and cared for them as part of their daily duties.

Stalls were equipped with an electrically operated barriers that would drop automatically when an alarm was received. The horses were trained to then be led out from their stalls to stand beneath their harnesses, which were suspended with wire from the ceiling. Once the horses were in position under the combination harness and open-swivel collar, the driver would then release the mechanism and the harness would drop over the horses. This system was aptly known as the "lightning hitch." Once the harness had dropped, the collar was then snapped around the neck of the horse by firefighters, and the apparatus was on its way in a very short time.

On their way to a fire, the horses normally pulled their heavy apparatus at a fast walk. Fire horses were only made to gallop when photographers wished to snap a picture of these brave animals "in action." Upon reaching the scene of a working fire, the horses were unhitched, blanketed, and taken to a safe place away from the tremendous noise and hot embers given off by the steamers.

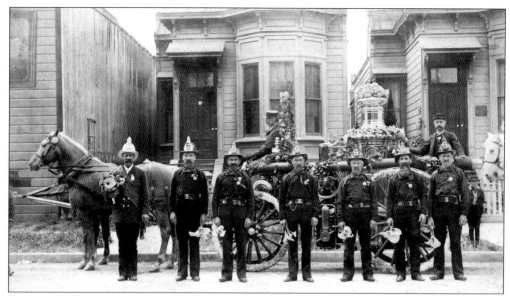

Garlands of flowers decorated Engine No. 5 for the annual Native Sons Parade in Oakland, in May 1896. Called Manhattan Engine Company No. 5 for many years, it is today one of the OFD's busiest engine companies. (Courtesy of the Oakland Fire Department.)

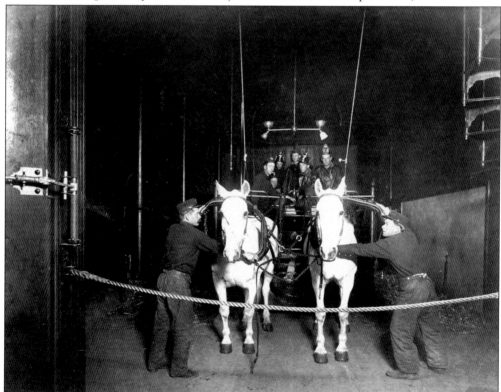

Shown here is the "lightning hitch" that hung suspended by wires over the apparatus floor and was used for many years by the OFD to quickly get a team of fire horses ready to go. (Courtesy of the Oakland Fire Department.)

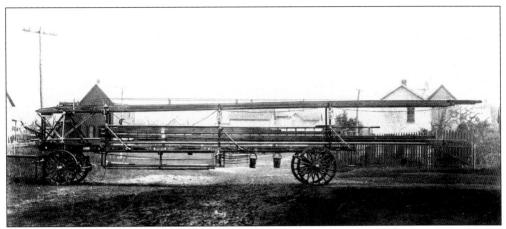

The Hayes Patent Fire Escape Truck, pictured here, was the first aerial ladder built for the fire service. Its inventor, Daniel D. Hayes, worked for the San Francisco Fire Department as their superintendent of steamers beginning in 1868. Hayes had two workshops in Oakland, where this first "modern" fire truck was manufactured. (Courtesy of the *Oakland Tribune*.)

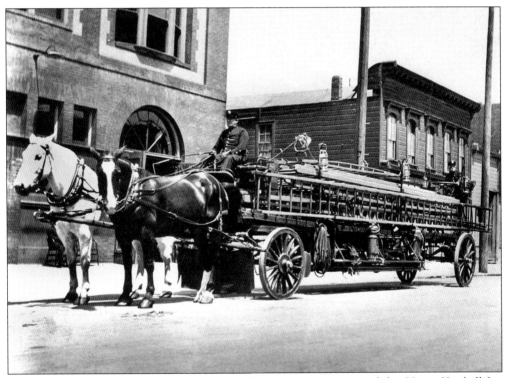

From 1879 until 1903, Oakland Hook and Ladder Company No. 1 used this Hayes-Kimball fire truck. It was a 4-wheeled, tillered, 85-foot wooden aerial ladder truck with a metal reinforced frame. (Courtesy of the Oakland Library.)

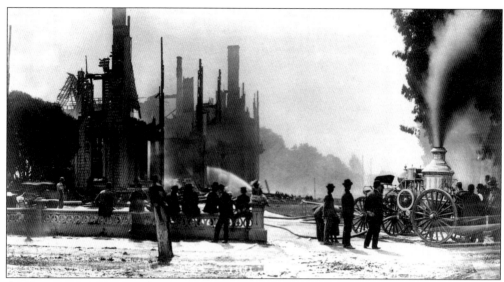

An OFD steamer continued to pour water on the smoldering remnants of the Tubbs Hotel the morning after it burned down. Located at Fifth Avenue and East Twelfth Street, the hotel was the largest structure in Oakland, built in 1879 by Hirum Tubbs at a cost of $200,000. The Tubbs Hotel Fire occurred on a clear summer day on August 14, 1893, and was described by onlookers as "the prettiest fire scene ever witnessed in the City." Unfortunately for the owner, the Tubbs Hotel had only $25,000 worth of insurance. (Courtesy of the Oakland Library.)

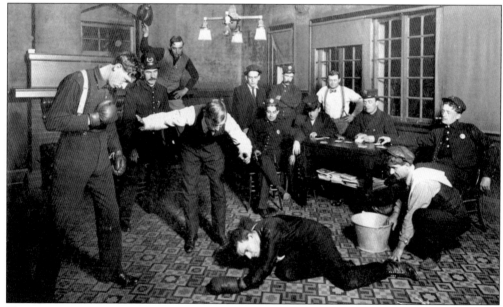

The year was 1910. It was a quiet day at Engine Company No. 9's quarters, so the boys decided to box. Connie Tamm (left) knocked out Art Crossman in the third round. Referee Bob Duncan counted out Crossman. The Oakland police officer next to Tamm is Con O'Grady. Ready with the bucket of water is George Wagner, and to his right is Al Vanucci. In the background are Harry Mulligan, W.J. McGuiness, Lou Hoffman (white shirt), and Henry Doody. (Courtesy of the Oakland Fire Department.)

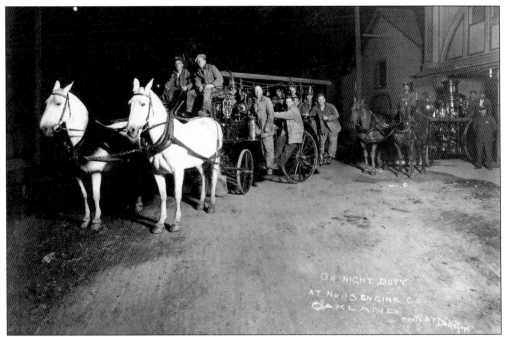

This c. 1910 Durston photograph is entitled "On night duty at No. 13 Engine Company, Oakland." Durston was a local photographer who took many staged pictures depicting firehouse life in Oakland during the early days of the 20th century. (Courtesy of the Oakland Fire Department.)

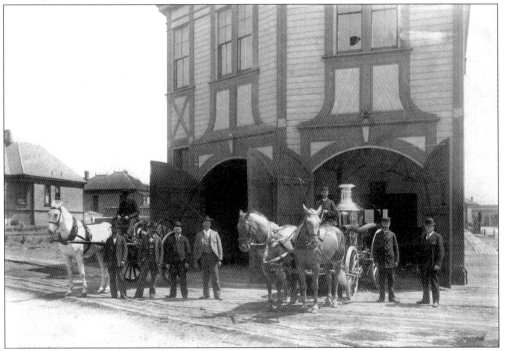

Pictured c. 1890 in front of their immense three-story fire station at 2500 Market Street in West Oakland are the men of Engine Company No. 5. (Courtesy of the Oakland Fire Department.)

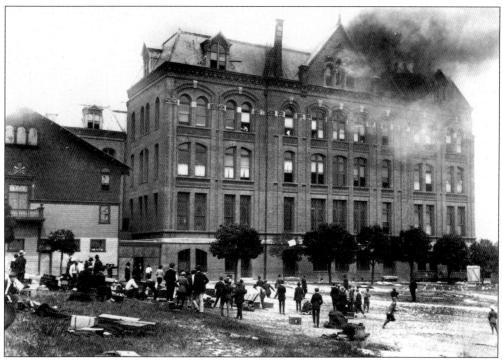

A fire broke out on the upper floors of St. Mary's College in Oakland in 1890. People can be seen looking out from several of the building's windows as a crowd gathers below, anticipating the arrival of the OFD. (Courtesy of the Oakland Library.)

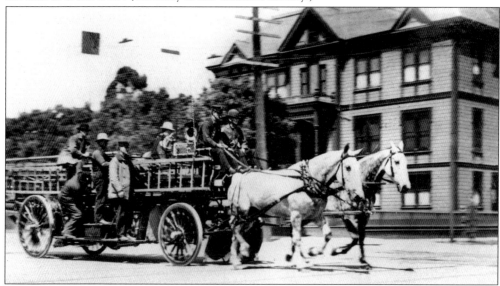

This July 4, 1910 photo shows the men of Truck Company No. 4 as they race down Telegraph Avenue at Fortieth Street. Their apparatus, a 1904 Halloway, was a four-wheeled city service truck that carried ground ladders but had no aerial ladder. It also had two 35-gallon, soda-acid chemical tanks connected to a 200-foot, 1-inch rubber-hose reel, which was used as a quick attack line. Truck Company No. 4 was organized on August 20, 1904. (Courtesy of the Oakland Fire Department.)

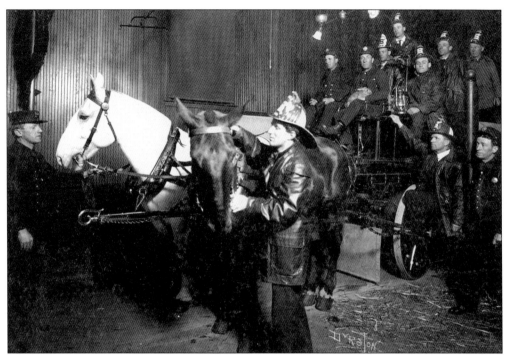

The horses of Truck Company No. 5 are almost ready to go in this Durston photograph taken around 1910. Truck Company No. 5 was quartered with Engine Company No. 7 at 1095 Fifty-ninth Street until 1918. Their mascot seems to have been a pet rabbit, which is sitting in the truck driver's lap. From 1918 until 1951, Truck Company No. 5's quarters were at Dover and Fifty-sixth Streets, where it was affectionately known as "Dover's Clovers." (Courtesy of the Oakland Fire Department.)

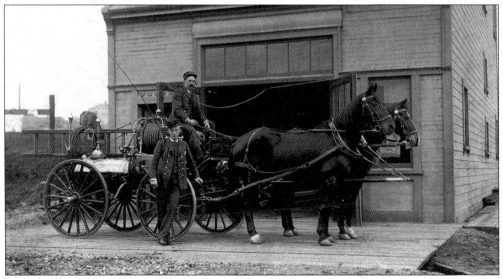

Chemical Company No. 3 is shown here in front of Engine Company No. 6's quarters at 2226 East Fifteenth Street in 1896. Their 1891 Holloway chemical wagon had one 60-gallon, soda-acid chemical tank and one 200-foot reel of chemical hose. (Courtesy of the Oakland Fire Department.)

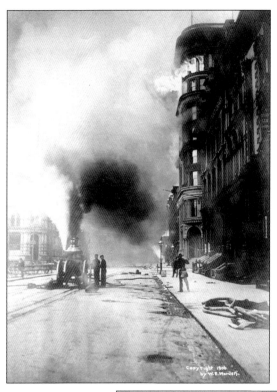

In response to San Francisco Mayor Schmidt's plea for "fire engines, hose, and dynamite" after the devastating 1906 earthquake and fire, Oakland immediately sent three fire engines across the bay via ferry boat. The dynamite, procured from several Oakland firms, was sent later. This picture shows an OFD steamer pumping valiantly in San Francisco on California Street on April 18, 1906. (Courtesy of Ed Clausen.)

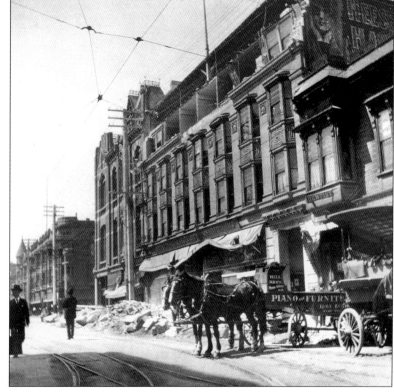

Oakland's downtown suffered extensive damage from the 1906 earthquake, as shown in this image taken during the cleanup efforts that followed. Many of the city's large brick buildings sustained major structural damage. Fortunately, Oakland did not experience any of the devastating fires that destroyed much of San Francisco. (Courtesy of the Oakland Library.)

Built of bricks and standing three stories tall, the OFD's Headquarters at Engine Company No. 1 did not fare well during the 1906 earthquake. The fire alarm center, which was housed on the top floor, was heavily damaged. Only after many weeks of repair were all of Oakland's fire alarm boxes back in working order. (Courtesy of the Oakland Fire Department.)

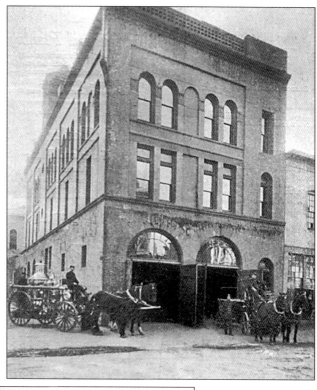

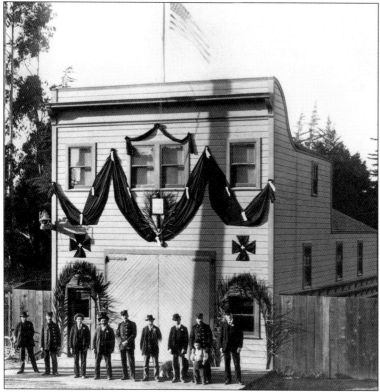

The quarters for the OFD's newest company, Engine Company No. 8 in the Temescal district, are all decked out for its grand opening on July 1, 1901. Prior to joining the OFD, this North Oakland neighborhood had its own fire department, known as the Temescal Volunteers. (Courtesy of the Oakland Fire Department.)

An Oakland cop stands alongside the men of Engine Company No. 14 at their quarters at 3461 Champion Avenue in the Dimond district, c. 1915. (Courtesy of the Oakland Fire Department.)

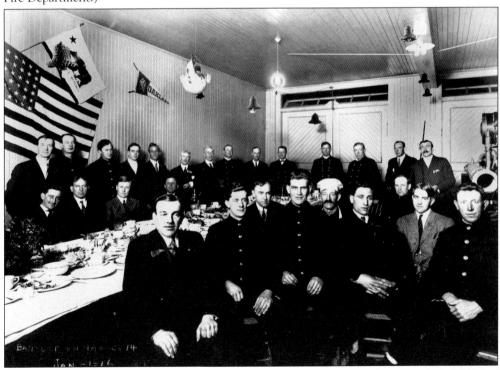

Durston took this picture of a banquet at Engine Company No. 14 in January 1916. The chef can be seen in the middle of the photograph wearing a white baking hat and apron. (Courtesy of the Oakland Fire Department.)

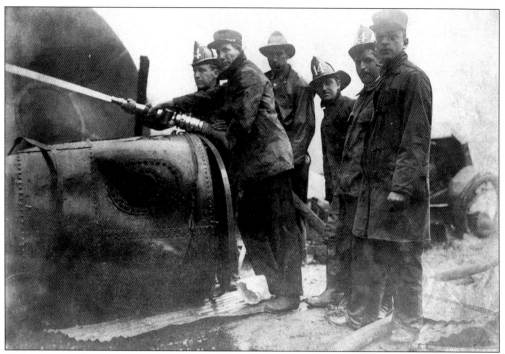

These images depict a huge 1913 fire at the Pacific States Oil Refinery in Oakland. The men of Engine Company No. 14 operate a "big line" in an attempt to douse the flames. Several large holding tanks caught fire, prompting the OFD to call a general alarm, which brought all available men and equipment to the scene. One of the holding tanks is seen here burning furiously out of control. (Courtesy of the Oakland Fire Department.)

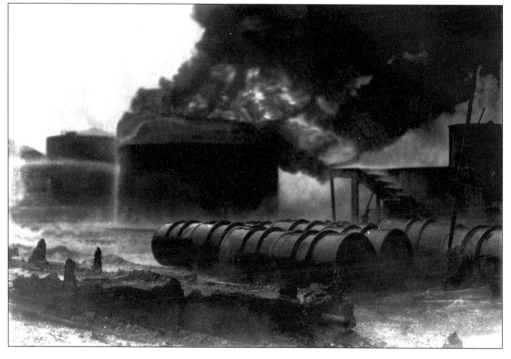

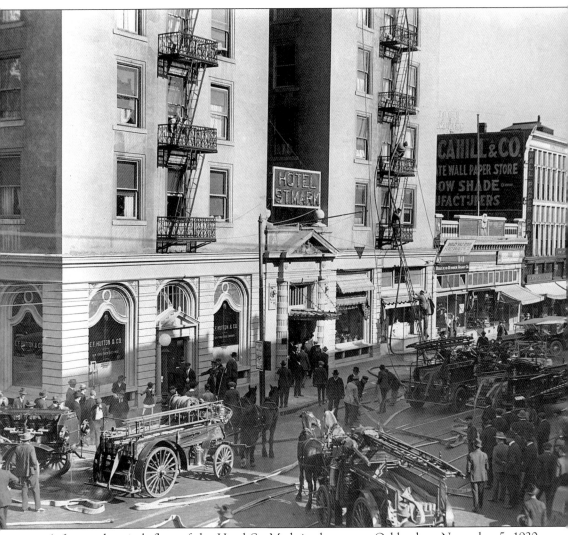

A fire on the ninth floor of the Hotel St. Mark in downtown Oakland on November 5, 1920, brought both motorized and horse-drawn units of the OFD to the scene. The front end of the massive Gorham, one of Oakland's first motorized fire engines, can be seen in the far left corner of the photo, supplying a hose line that snakes its way up the fire escape. (Courtesy of the Oakland Fire Department.)

Three
MOTORIZATION (1908–1922)

One of the most interesting chapters of Oakland Fire Department history was the complete motorization of the department in the early 1920s, bringing the days of the brave fire horse to a close. Motorization was a concern shared by Chief of Department Whitehead and fire chiefs across the nation. The small size and lack of dependability of the early motorized fire engines made this technology seem a bit dubious. Horses never failed to start, but many early fire engines often did.

Oakland's first steps toward motorization were taken when the department began replacing the small buggies drawn by a single horse that were being used by chief officers. The first chief's car was placed into service by the OFD in 1908. These new buggies were a variety of Columbia, Velies, Lozier, and Cadillac automobiles. In 1911, the OFD purchased a Nott 600 gpm (gallons per minute) Double-Combination Pumper (it carried no water). This technological marvel of the day went into service as Engine Company No. 14 on July 25, 1912. During the next decade, the remainder of all Oakland engine, hose, and truck companies received new motorized apparatus. It is thought that Engine Company No. 5, located at Milton and Market Street, was the OFD's very last company to become motorized in 1922.

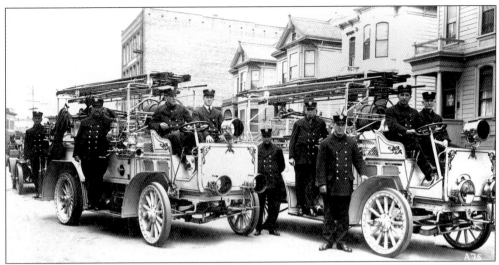

Built in 1911, these two Seagrave hose-chemical combination wagons were part of Oakland's first attempts to use motorized fire apparatus. Painted white, the men dubbed these ungainly, slow, and somewhat unreliable rigs "White Wagons." Assigned to Engine Company No. 12 and Hose-Chemical Company No. 2 respectively, these two units were part of the OFD until the late 1920s. (Courtesy of the Oakland Fire Department.)

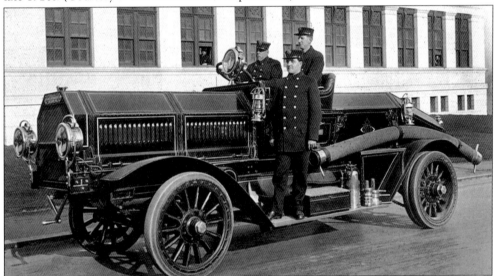

In 1911, the OFD purchased a Gorham fire engine, seen here in front of the new Fire Alarm Building, at a cost of $9,500. The *Pacific Fireman* magazine had this to say about the OFD's latest marvel in engineering:

> The engine is of the multi-stage turbine type, with a 6-cylinder motor, 7-inch bore, 9-inch stroke and develops 144 horse power at 1,000 piston strokes per minute. The pump is fitted with a 6-inch suction and three 3-inch discharge gates; is made of gun bronze, is rated extra first size and is capable of delivering 1,100 gpm in efficient fire streams.

Although built on a Seagrave chassis, the Gorham Company of Oakland, California, built the engine and pump. (Courtesy of the Oakland Fire Department.)

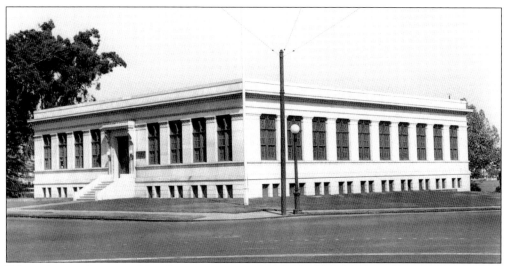

When Engine Company No. 1's quarters were damaged in the 1906 earthquake, much of the OFD's primitive fire alarm system was also damaged. At the recommendation of Mayor Mott, the OFD built its 1911 fire alarm building out of fireproof materials, on a separate city block near Lake Merritt. Designed by Walter J. Matthews, Oakland's most renowned architect, the fire alarm building served as the nerve center for the OFD until 1983, when a new, state-of-the-art 911 dispatch center was opened at Engine Company No. 1's quarters. (Courtesy of the Oakland Fire Department.)

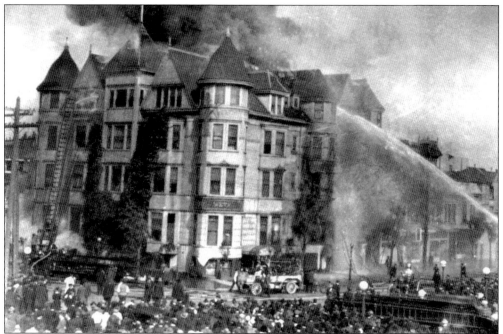

A black plume of smoke rises into the summer sky in this August 1918 photograph, as fire rages through the fifth floor of the Metropole Hotel at Thirteenth and Jefferson Streets. Several ladders have been thrown to the upper floors as Oakland firefighters try vainly to stop the blaze. A Seagrave "white wagon" can be seen parked in front of the doomed hotel as a huge crowd gathers to watch the spectacle. (Courtesy of the Oakland Fire Department.)

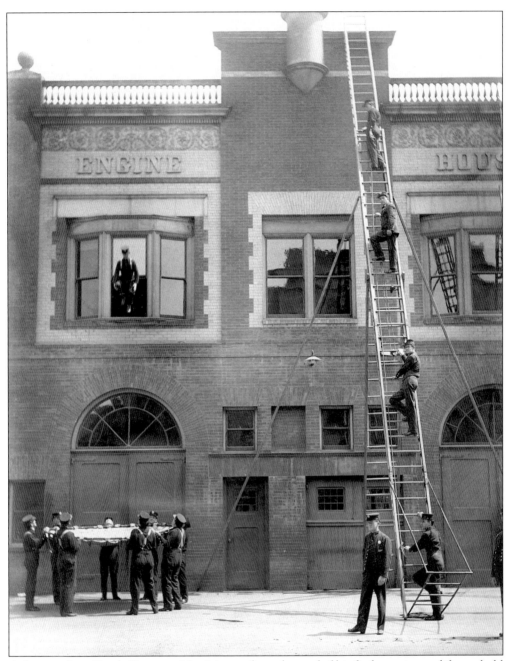

A fireman from Truck Company No. 1 jumps from the roof of his firehouse into a life net held by his fellow "truckies" in this unique photograph, c. 1915. All Oakland truck companies carried life nets. Although life nets were somewhat effective in saving those jumping from heights below 50 feet, firefighters preferred using ladders to rescue civilians. Life nets were phased out of the OFD during the 1970s. (Courtesy of the Oakland Fire Department.)

Located at 1681 Eighth Street, Engine Company No. 3 and Truck Company No. 3's old quarters housed this strange mix of motorized and horse-drawn apparatus for only a short time. The horse-drawn engine was an 1889 American LaFrance steamer with a 600-gpm double-piston pump. The OFD Shop built the motorized truck by piecing together a 1914 Cadillac Roadster (a former chief's buggy) and an 1898 Babcock city service truck. This 1918 photograph illustrates the incredible technological advances made by fire departments across the country during the first part of the 20th century and the ingenuity and thrift of the OFD in adapting to these changes. (Courtesy of the Oakland Fire Department.)

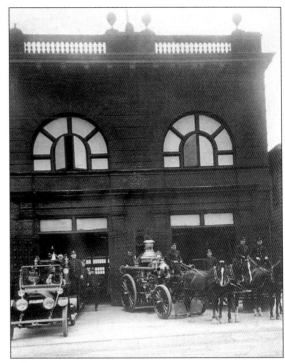

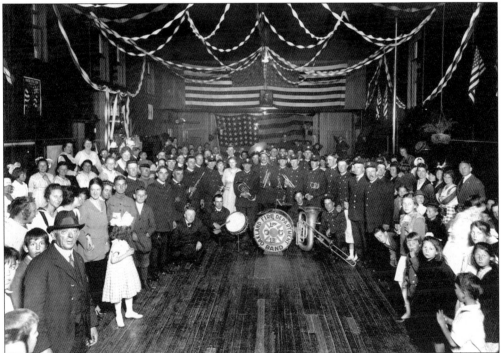

A dance was held in Truck Company No. 5 and Hose-Chemical Company No. 2's quarters in the summer of 1918. The chemical wagon and fire truck were parked outside and the apparatus floor was turned into a dance hall. Music was provided courtesy of the OFD Band. (Courtesy of the Oakland Fire Department.)

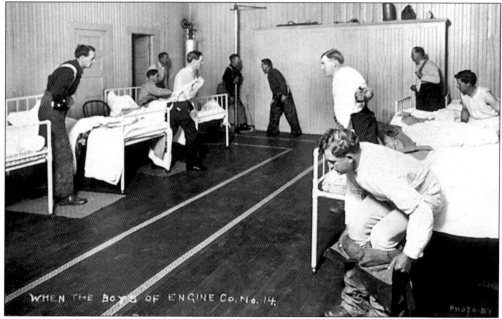

This Durston photograph is entitled, "When the boys of Engine Company No. 14 are awakened by the clanging gong." Living conditions for the men of the OFD prior to the 1930s ranged from decent to deplorable. Some companies with modern quarters such as Engine Company No. 14 lived in clean, modern, open dormitories, while others lived in much older buildings that were little better than barns. (Courtesy of the Oakland Fire Department.)

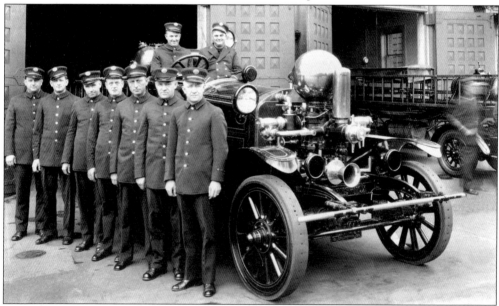

The men of Engine Company No. 3, in dress uniform, stand proudly with their beautiful 1915 Ahrens-Fox triple-combination pumper. This unique apparatus, with its signature front-mounted chrome-plated pump, served as Engine Company No. 3 from 1925 until 1940 and was capable of providing 750 gpm. (Courtesy of the Oakland Fire Department.)

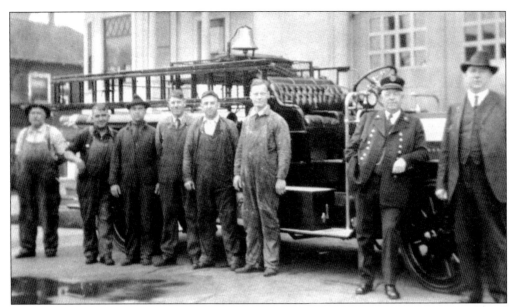

Chief of Department Samuel Short stands alongside Superintendent of Engines McFeely and members of the OFD Shop in 1925. The shop was charged with maintaining Oakland's vast fleet of fire apparatus, and did an outstanding job of it. In order to save the city money, the shop built many types of fire apparatus from the ground up that were utilized by the OFD. (Courtesy of the Oakland Fire Department.)

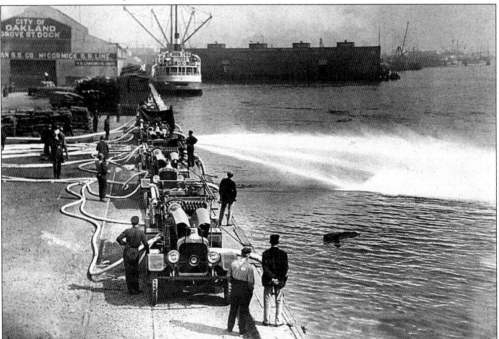

All OFD fire apparatus, before being put into service, must undergo rigorous acceptance testing. Fire engines must be able to draft and pump for specified periods of time while maintaining proper pressure and temperature. These brand-new Seagrave fire engines were put through their paces at the Ninth Street Pier, c. 1922. (Courtesy of the Oakland Fire Department.)

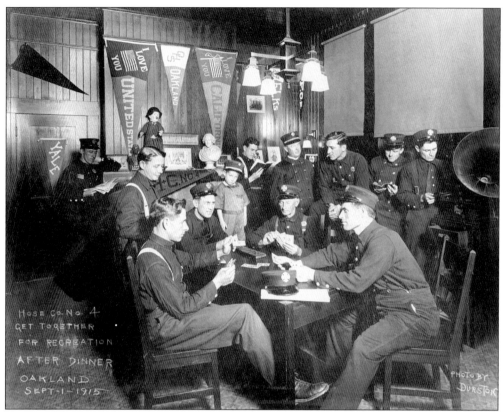

"Hose Company No. 4 Get Together for Recreation after Dinner" is the title of this Durston photograph, dated September 1, 1915. Note the shy young lad in the middle of the picture and the Charlie Chaplin doll on the mantle. (Courtesy of the Oakland Fire Department.)

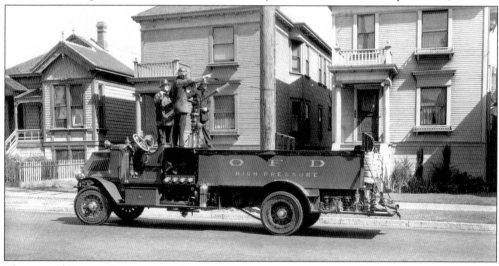

The men of Engine Company No. 12 practice setting up the massive deck gun mounted on their 1925 Mack high-pressure hose wagon. Fed by eight three-inch manifolds, the high pressure turret was capable of delivering a powerful stream of water a great distance. (Courtesy of the Oakland Library.)

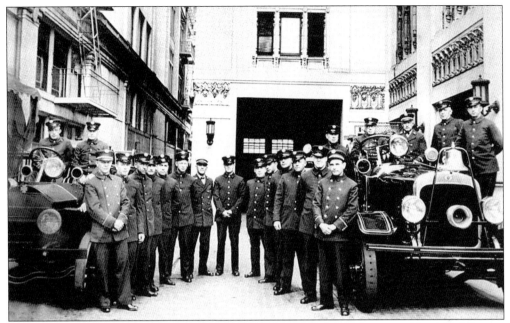

In 1914, Oakland City Hall became home to the men of Engine Company No. 1 and Engine Company No. 12. Living quarters were in the basement, and apparatus exited out of a garage located on the Fourteenth Street side of the building. In this c. 1925 photo, the men of both companies pose with their apparatus. (Courtesy of the Oakland Fire Department.)

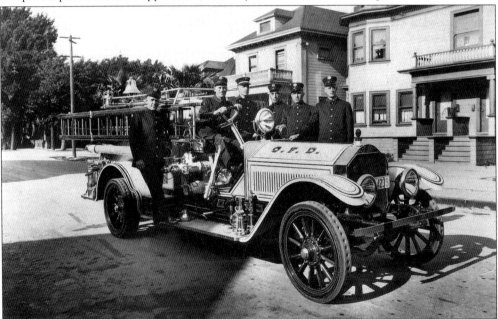

Standing in front of their quarters at 2228 East Fifteenth Street are the members of Engine Company No. 6 and their first motorized apparatus, a Type 45 American LaFrance triple combination pumper. Capable of pumping 1,000 gpm, it was fast and reliable. These second-generation motorized fire engines spelled the end of the venerable fire horse in Oakland. (Courtesy of the Oakland Fire Department.)

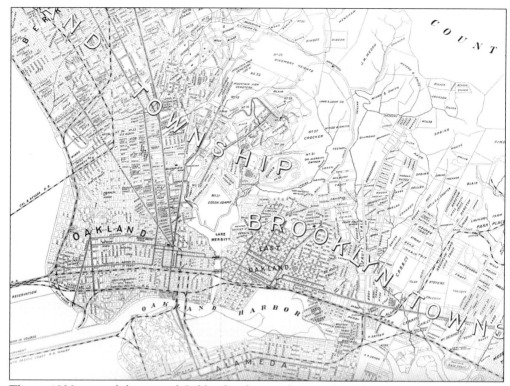

This c. 1920 map of the city of Oakland indicates that much of the land, especially in East Oakland, had yet to be developed. Old townships, such as Brooklyn, retained their original names. The small volunteer fire departments that had protected these little towns were incorporated into the OFD by 1909. (Courtesy of Mr. and Mrs. Goldsmith.)

Four
MODERNIZATION (1922–1955)

At the close of World War I, the Oakland Fire Department had transformed itself from a mostly volunteer organization to a fully paid, professional municipal fire department. Department welfare organizations such as the Heath Club, the Relief Fund, and the Firefighter's Union–IAFF Local No. 55, took steps in the early 1920s to prepare certain charter amendments, including the creation of a two-platoon work schedule, to make the department more efficient and strengthen civil service regulations as they applied to the OFD. Voters approved the measures that went into effect on January 1, 1920, and added 104 men to the ranks of the OFD.

The OFD's first African-American firefighters were hired in 1920 by Chief Elliot Whitehead. They were initially assigned to Engine Company No. 11, the high-pressure wagon, and were commanded by white officers. In order to separate the African-American firefighters from their white counterparts, Engine Company No. 22 (formerly Chemical Company No. 2) was opened in April 1926 at Thirty-fourth and Magnolia Streets in West Oakland. Until the 1940s, Oakland would not allow any African-American firefighters to be promoted. Instead they were assigned to white officers, who had been sent to Engine Company No. 22 as punishment. Chief of Department Samuel Short thus began a 30-year period of racial segregation in the department.

Chief Lutkey took the helm of the OFD in 1927, and held the position for 20 years, the longest tenure of any chief of department in Oakland's history. He was saddled with trying to run the department during the Great Depression. For many years, the OFD made do without any increase in budget or personnel. Following Chief Lutkey's retirement in 1947, Fire Chief James Burke was faced with transforming a department that had changed little since the mid-1920s.

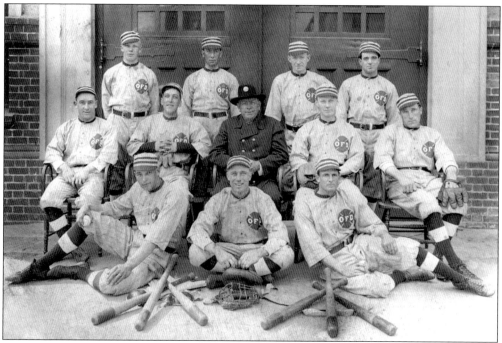

Dressed in their pinstriped uniforms, the men of the OFD baseball team posed for a photograph in the early 1920s. Their coach, in dress uniform, was an assistant fire chief. The tradition of OFD firefighters playing organized sports continues to this day in the form of the annual Firefighter Olympics. (Courtesy of the Oakland Fire Department.)

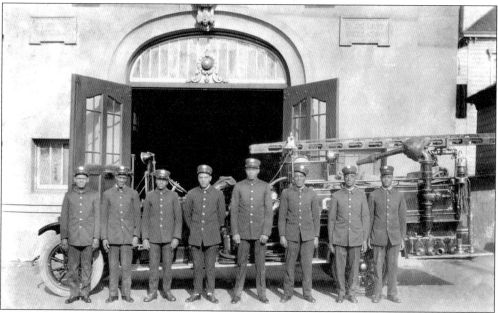

When the Oakland Fire Department hired the first African-American firefighters in 1920, they were initially assigned to Engine Company No. 11 in downtown Oakland. Eight of these firefighters are pictured with the high-pressure hose wagon in front of Engine Company No. 11's quarters on Alice Street, c. 1925. (Courtesy of Ed Clausen.)

Organized on November 28, 1916, by Oakland businessman R.B. Heath, the Heath Club was a fraternal organization that strove to ensure that civil service laws were enforced, to strengthen the merit system, and work to improve the general welfare of members of Oakland's police and fire departments. Heath's son and grandson would later both become members of the OFD. (Courtesy of the Oakland Fire Department.)

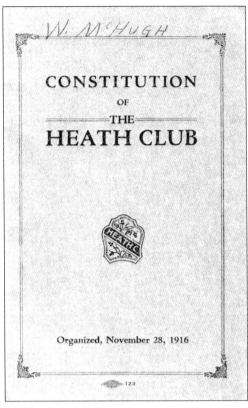

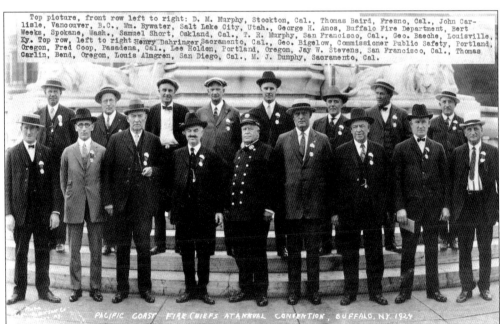

Oakland Fire Chief Samuel Short (first row, third from the right) stands with his peers at the annual Pacific Coast Fire Chiefs Convention, held in Buffalo, New York, in 1924. (Courtesy of the Oakland Fire Department.)

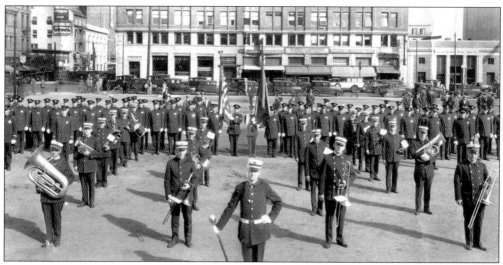

Standing proudly at attention before a crowd of onlookers in downtown Oakland is the OFD Band, pictured here in 1925. The Oakland Police Department Color Guard, as well as many police officers, can be seen in the background. (Courtesy of the Oakland Fire Department.)

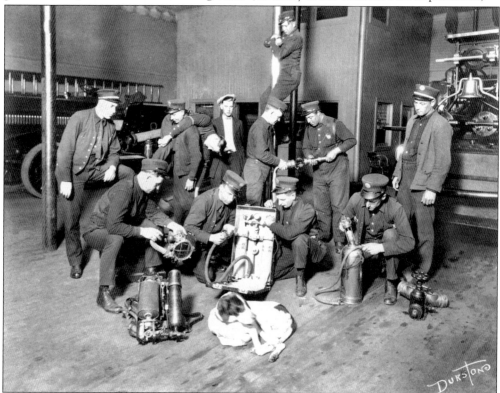

The men of Engine Company No. 2 and Truck Company No. 1 show off their state-of-the art firefighting equipment on January 24, 1925, in this photograph by Durston. One fireman in the foreground examines a crude self-contained breathing apparatus, while two others look at the latest medical equipment of the day, a portable "inhalator" oxygen tank. (Courtesy of the Oakland Fire Department.)

A fire rages in a church next to the Orpheum Theater at Twelfth and Clay Streets, c. 1927. The high-pressure hose wagon can be seen in the background using its massive deck gun to douse the flames. (Courtesy of the Oakland Fire Department.)

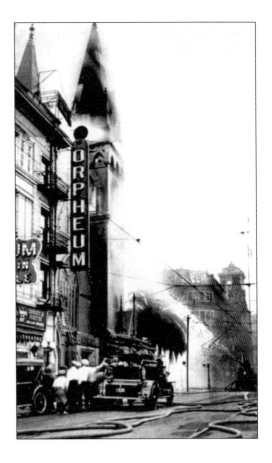

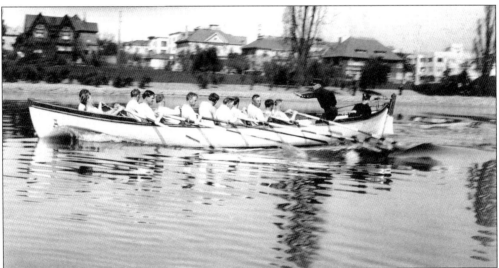

During the 1920s, the OFD had its own rowing team. They are pictured here racing across beautiful Lake Merritt, while the coxswain gives the crew encouragement. Their boat, when not in use, was kept at the high-pressure pumping plant, located on the 1500 block of Oak Street. (Courtesy of the Oakland Fire Department.)

The men of Engine Company No. 18 and Truck Company No. 6 stand in front of their new quarters at 1700 Fiftieth Avenue in this c. 1926 photograph. A local businessman, Henry Root, donated the land for the new fire station in the Melrose District of East Oakland. This firehouse was one of the first built solely for motorized fire apparatus, and still proudly serves the city of Oakland today. (Courtesy of the Oakland Fire Department.)

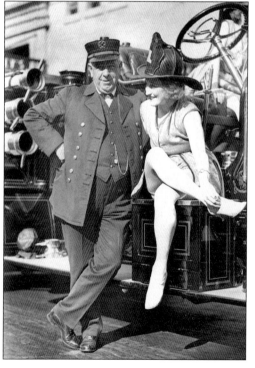

Chief of Department Samuel Short stands next to a flapper in this June 1922 photograph. The image was used to publicize a benefit show to raise funds so that the OFD could play host to the International Fire Chiefs Convention, held in August of that year. (Courtesy of the Oakland Fire Department.)

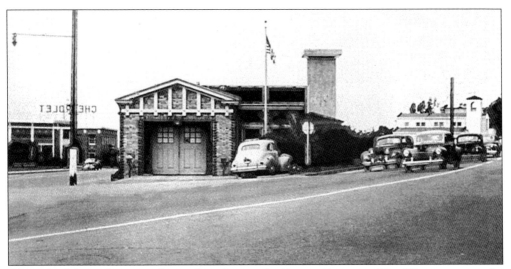

Chevrolet Motor Company donated to the site for Engine Company No. 23's quarters to the city of Oakland. Chevrolet's massive automobile manufacturing plant can be seen in the background of this photograph. During the first half of the 20th century, Oakland was known as the "Detroit of the West" because of its many ties to the growing automobile industry. Organized on March 2, 1925, Engine Company No. 23 serves the Eastmont District in East Oakland and is today one of OFD's busiest companies. (Courtesy of the Oakland Fire Department.)

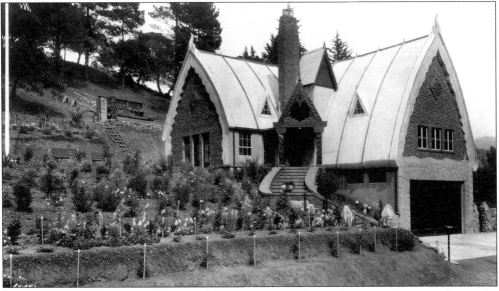

Many of Oakland's wealthiest citizens began moving to the city's upper elevations during the 1920s. Berkeley, Oakland's neighbor to the north, had suffered a devastating fire in the hills above the University of California in 1923 that left 4,000 people homeless. The "Wildcat Fire" began a pattern of fires in the hills of Oakland that would continue to repeat itself every 20 years or so, with tragic consequences. The OFD addressed the growing threat of fire in the hills by organizing Engine Company No. 24 on September 3, 1927. Designed, apparently, with the Hansel and Gretel fairy tale in mind, it was affectionately dubbed the "Gingerbread House" by residents of prestigious Montclair Village. (Courtesy of the Oakland Fire Department.)

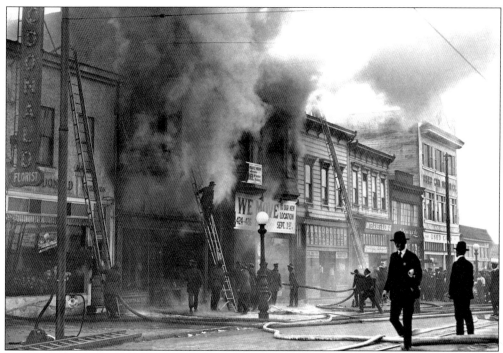

A man wearing a bowler hat and carrying a newspaper steps gingerly over fire hoses that twist their way through the streets of downtown Oakland, while another fixes his gaze upon the brave firemen at the scene of a working fire in a commercial building around 1930. (Courtesy of the Oakland Fire Department.)

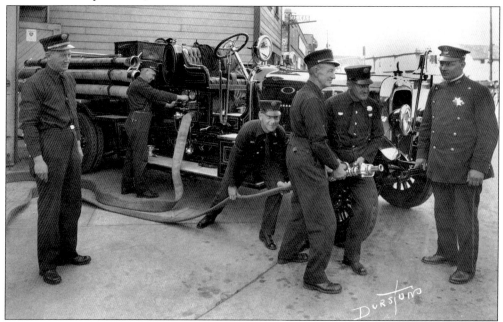

An Oakland police officer looks on as the veteran firemen of Engine Company No. 14 complete a hose evolution in this Durston photograph dated March 17, 1925. (Courtesy of the Oakland Fire Department.)

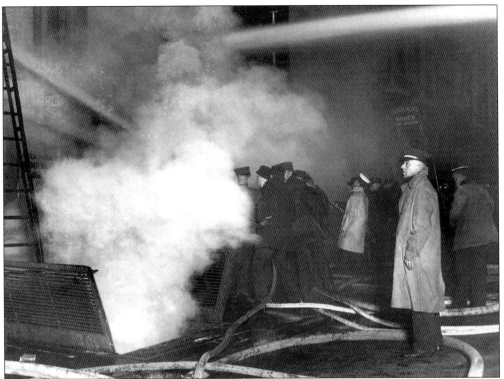

Oakland firemen battle a stubborn cellar fire in downtown Oakland on Thirteenth Street between Clay and Washington Streets in this 1930s photograph. (Courtesy of the Oakland Fire Department.)

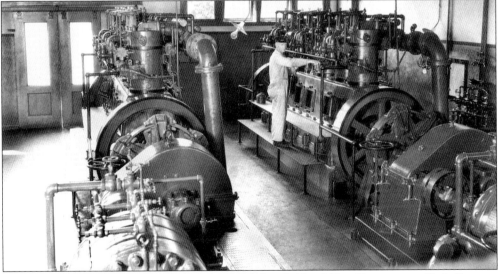

These massive engines powered the pumps of the Oakland Fire Department High-Pressure Pumping Plant, nestled on the shores of Lake Merritt. Designed to augment the OFD's water supply in the event of a catastrophic failure, these huge pumps could deliver salt water drafted from Lake Merritt into a separate auxiliary water supply system for Oakland's downtown. A fire officer and an engineer from the OFD staffed the plant. (Courtesy of the Oakland Library.)

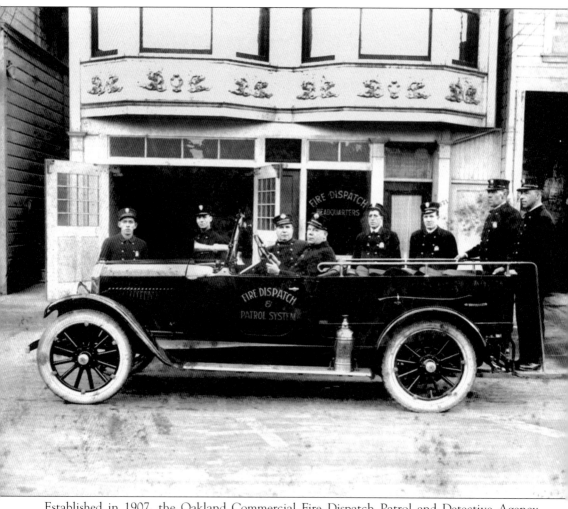

Established in 1907, the Oakland Commercial Fire Dispatch Patrol and Detective Agency was a private company, owned and operated by "Chief" F.C. Schwarting. His company provided fire protection and night watchman service by uniformed watchmen at all hours for those Oakland businesses willing to pay for this extra service. (Courtesy of the Oakland Fire Department.)

Onlookers on Sixth Street gaze up at an Oakland fireman climbing to the tip of Truck Company No. 1's 85-foot wooden, aerial ladder in this 1934 photograph. (Courtesy of the Oakland Library.)

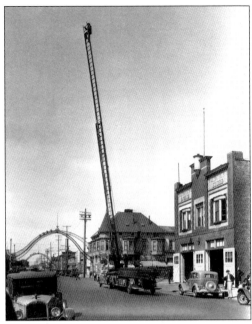

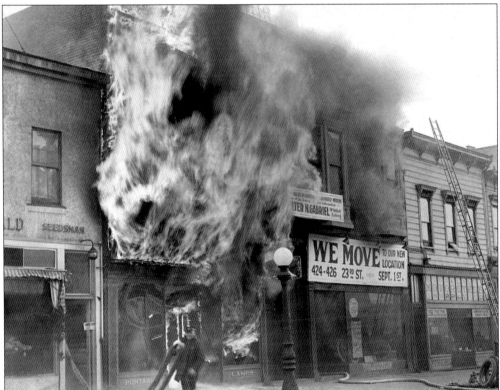

This unidentified Oakland fireman stretches a hose line before beginning to attack this well-established fire in a "taxpayer" (a multi-story building with commercial occupancies at street level and residential occupancies on the upper floors) in this photograph from the 1930s. (Courtesy of the Oakland Fire Department.)

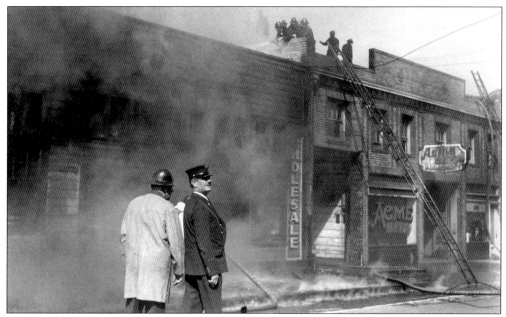

An unidentified Oakland battalion chief (left) and his operator watch as the battle to control a fire in a commercial building rages. Chief's operators were assigned to drive their designated chief and to assist them with managing emergencies once they arrived on the scene. This invaluable position was eliminated by the City of Oakland in the late 1980s due to budget cuts. (Courtesy of the Oakland Fire Department.)

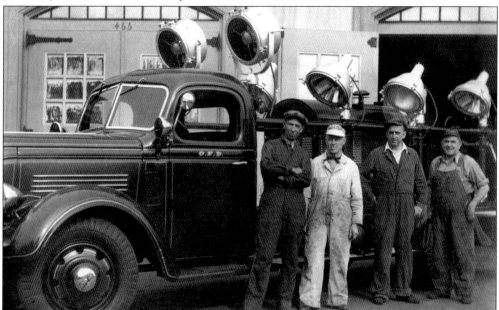

Four members of the Oakland Fire Department Shop, Clarence Mills, Art Brazelton, George Kingston, and Billy Altenhoff, stand in front of their newest creation in 1937. Light Unit Company No. 1 was a shop-built floodlight unit mounted on a 1936 GMC truck. It carried a 10,000-watt Kohler generator and was equipped with six 1,000-watt lights, two 500-watt lights, six 250-watt lights, and six cable reels. (Courtesy of the Oakland Fire Department.)

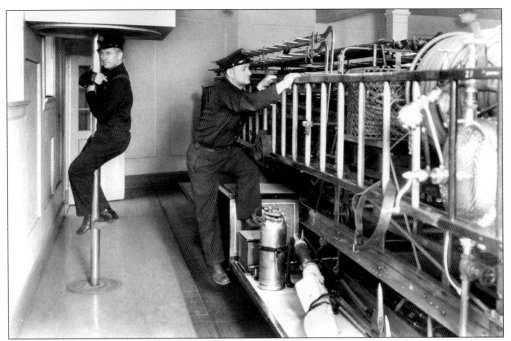

This December 8, 1933 photograph captures a fireman from Truck Company No. 6 sliding down a brass pole, while another member of his company clambers onto the fire truck. Many modern firehouses in Oakland continue to be built with brass poles. This tradition of using brass poles enables the Oakland firefighter of today to get from the living quarters upstairs to the fire apparatus located on the ground floor in a matter of seconds. (Courtesy of the Oakland Library.)

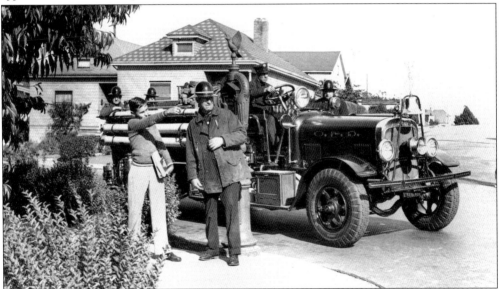

After pulling a fire-alarm box, a schoolboy describes his emergency to the officer of this Oakland engine company. Prior to the 911 system, most alarms received by the OFD were sent in by these fire-alarm boxes. Fire companies responding to an alarm usually had no idea what to expect until they arrived on the scene and assessed the situation. False alarms were frequent and a source of frustration for firefighters. (Courtesy of the Oakland Library.)

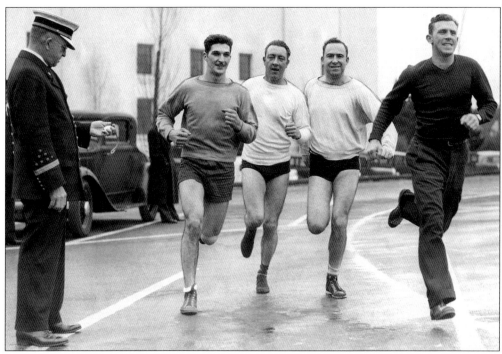

Candidates wanting to join the ranks of the OFD had to undergo a number of strenuous physical tests in order to be considered for employment. Here, several potential firefighters finish a half-mile race as Chief Lutkey records their times on his stopwatch in this photograph taken on March 27, 1939. (Courtesy of the *Oakland Tribune*.)

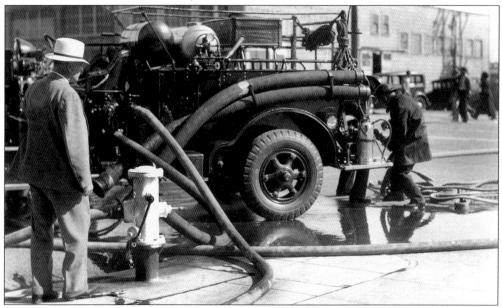

A bystander watches curiously as two members of this Oakland engine company connect their fire hose together at the scene of a working fire in the 1930s. When this photograph was taken, hoses were constructed of cotton, had brass couplings, and were much heavier than the synthetic fire hoses of today. (Courtesy of the Oakland Library.)

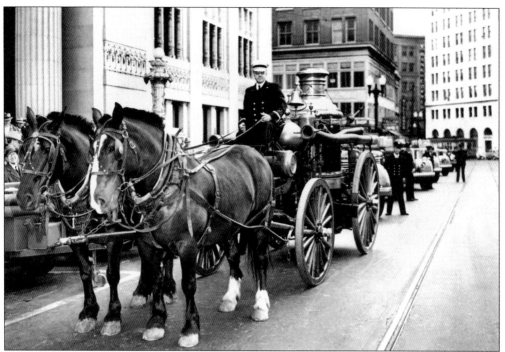

Chief Lutkey takes a trip down memory lane as he sits aboard an old OFD steamer in front of city hall on May 11, 1942. As a young man, he was the driver of Chemical Company No. 1 during Oakland's horse-drawn days, 40 years earlier. Now, near the end of his 20-year tenure as chief of department, he proudly inspects Oakland's newest motorized fire apparatus. (Courtesy of the Oakland Fire Department.)

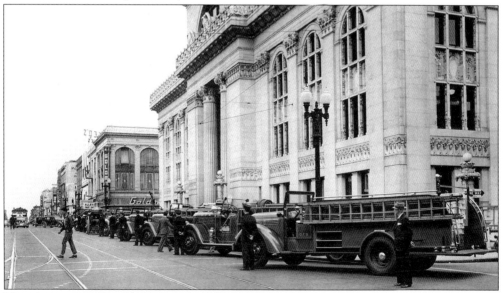

Manufacturer Pirsch and International delivered seven new pieces of apparatus to Oakland in May 1942. The OFD proudly displayed four hose wagons, two engines, and one 85-foot aerial ladder truck to the public in front of city hall prior to putting them into service. (Courtesy of the Oakland Fire Department.)

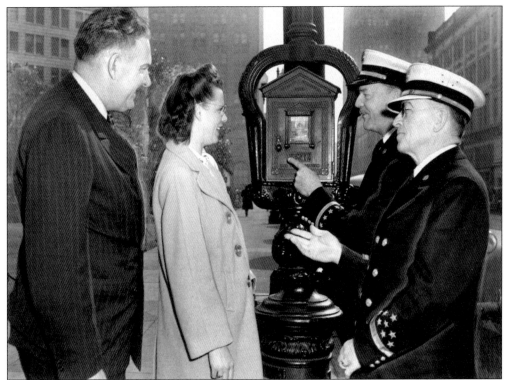

"Know where your nearest fire alarm box is and use it when fire breaks out in your home!" is the admonition Fire Chief William Lutkey and Fire Marshall Fred Carlson of the Oakland Fire Department, and Clayton Hess, accident prevention chairman of the Oakland Red Cross, give to Mrs. Bryan Carter of 2449 Twenty-sixth Avenue, c. 1946. (Courtesy of the Oakland Tribune.)

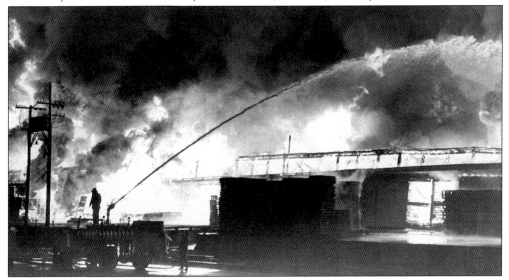

The water from this unidentified OFD hose wagon seem to have no effect on a massive conflagration at the Oakland Army Base on March 15th, 1949. This spectacular six-alarm blaze was the work of an arsonist and caused a record $10 million in damage before being brought under control. (Courtesy of the Oakland Fire Department.)

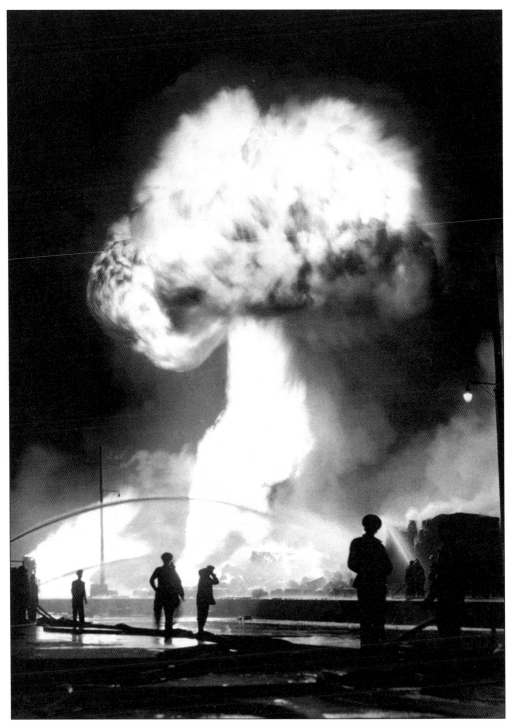

Oakland firemen stand in awe as a tremendous explosion rips through the night sky, forming an enormous mushroom cloud above their heads. What looks like an atom bomb blowing up is actually a 50-gallon drum of flammable liquid exploding at the Oakland Army Base during the March 15, 1949 fire. (Courtesy of the Oakland Fire Department.)

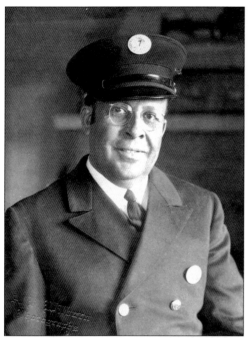

Royal Townes joined the OFD in 1927 and was assigned to Engine Company No. 22, the segregated firehouse in West Oakland. Ambitious and bright, he worked to make African-American firefighters eligible for promotional opportunities. Townes collected data from fire departments throughout the country to prove that African Americans were being promoted up the chain of command in cities like Philadelphia, New York, and Kansas City. He was the first of his race to be promoted in the OFD, became chief's operator in 1941, and retired with the rank of lieutenant in 1962. (Courtesy of Eric Logan.)

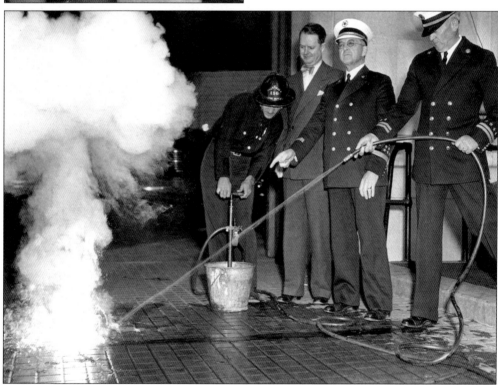

In this 1942 photo, Assistant Fire Chief Burke demonstrates the proper way to use a stirrup-type pump fire extinguisher of British design (which was credited with saving London during the Blitz) while Chief Lutkey explains the device's technical details to a crowd of reporters. (Courtesy of the *Oakland Tribune*.)

In this 1942 photograph, Fire Marshall Fred Carlson has an unidentified hoseman model the OFD's latest self-contained breathing apparatus (SCBA) developed by the U.S. Navy, while speaking before a community group. (Courtesy of the *Oakland Tribune*.)

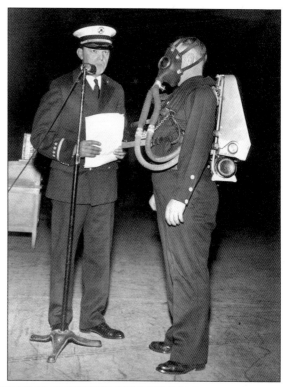

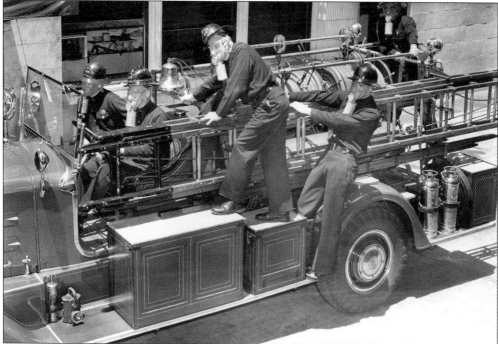

At the start of World War II, members of the OFD were issued protective masks in the event of a Japanese gas attack. Pictured here are the members of Chemical Company No. 1, who gave a demonstration to the public on July 3, 1942. (Courtesy of the *Oakland Tribune*.)

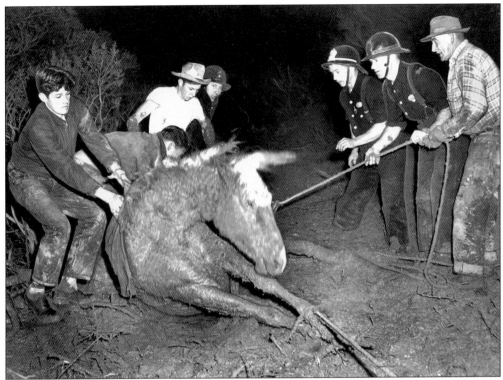

Candy the horse gets a helping hand from the OFD on January 26, 1951, after getting herself stuck in the mud. Hoseman Eddie Ashbaumer, Lt. Ted Malquist, and Hoseman Paul Smith all assist in the rescue. (Courtesy of the Oakland Fire Department.)

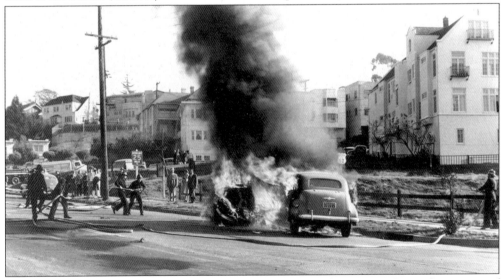

A runaway truck was the cause of this car fire on November 13, 1947, at the corner of MacArthur Boulevard and Lakeshore Drive. The crew of Engine Company No. 10 prepares to extinguish the blaze. A young fire buff named Don Matthews, who would later join the OFD and rise through the ranks to become the first assistant chief, took this photograph. (Courtesy of the Oakland Fire Department.)

A fire at the Best Fertilizer Company sent several members of the OFD to the hospital with chemical burns. This unidentified fire officer sustained burns to his face. (Courtesy of the Oakland Fire Department.)

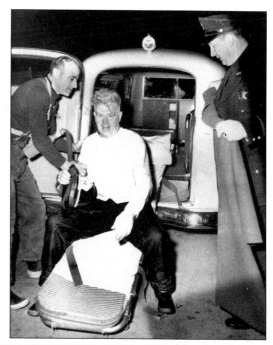

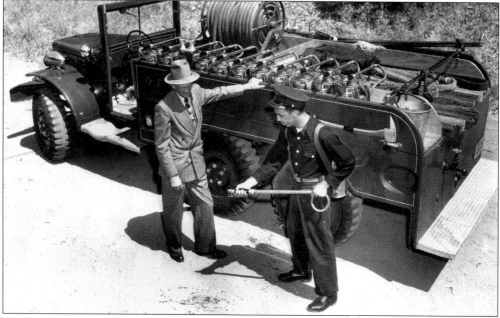

Hoseman Milo Gaskin of Engine Company No. 33 demonstrates how to properly use an "Indian pump," a back-mounted, manual fire extinguisher used for wildland firefighting. Engine Company No. 33, a Navy-surplus tank wagon mounted on a six-by-six chassis, stands ready to go in the background. On a social note, by the mid-1940s Engine Company No. 22 was still the OFD's only segregated engine company. Thirteen or fourteen African-American firefighters were on duty at any given time. To relieve this overcrowding, the OFD opened two more segregated two-man companies in Oakland Hills–Engine Company No. 33 in 1944 and Engine Company No. 28 in 1948. (Courtesy of the *Oakland Tribune*.)

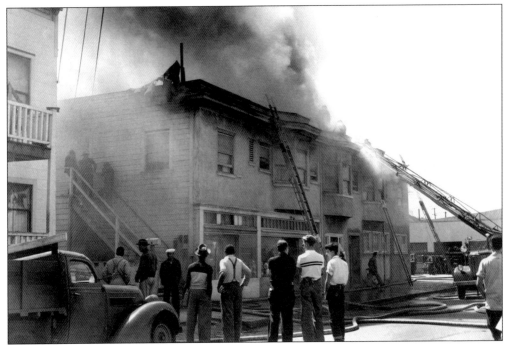

Onlookers watch a working two-alarm fire in a Victorian-era "taxpayer" at 1234 Center Street in West Oakland in the early 1950s. During the OFD's first 100 years, most of the busy firehouses were located in downtown or West Oakland. Firefighters from Truck Company No. 3 can be seen opening a hole in the roof with axes and pike poles, allowing for super-heated gas and flames to vent from this makeshift chimney. (Courtesy of the Oakland Fire Department.)

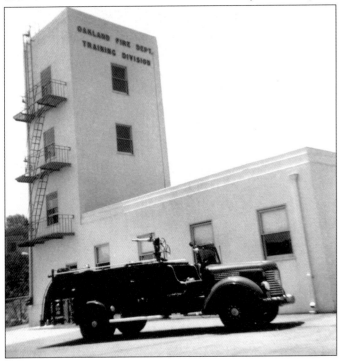

The OFD's first drill tower was built in the late 1940s under the direction of Chief Burke. A visionary fire chief, Burke wanted Oakland's drill tower "to be utilized for an all-out, continuous training program for firemen." Parked in front of the drill tower is Hose Wagon Company No. 15. (Courtesy of the Oakland Fire Department.)

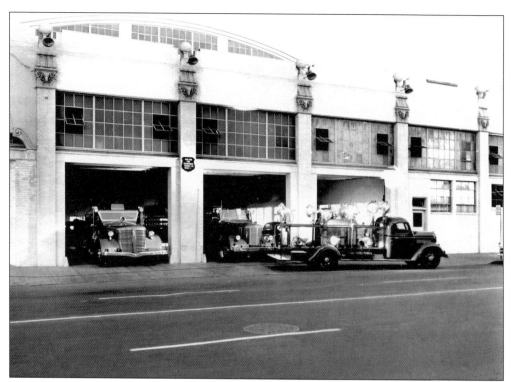

On February 1, 1949, the OFD moved into its new headquarters at 1330 Grove Street in downtown Oakland. The building served as a skating rink and a grocery store before being turned into a firehouse. Initially quartered in this cavernous building were Engine Company No. 1, Engine Company No. 32, Truck Company No. 1, Light Unit Company No. 1, and the first assistant chief. In addition to these front line units, Station No. 1 was home to the OFD Shop as well as the offices of the chief of department and his administration. (Courtesy of the Oakland Fire Department.)

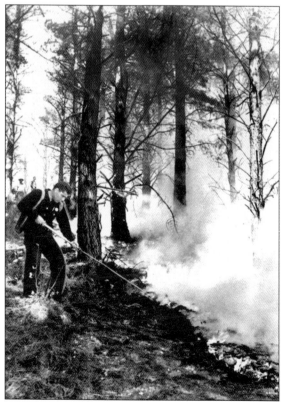

A "new kid" (the OFD's term for a probationary firefighter) named Ray Dossa uses an Indian pump to cool hot spots on a small vegetation fire in the hills of Oakland in 1950. Battalion Chief Ray Dossa retired in 2003 after 54 years of honorable service in the Oakland Fire Department. (Courtesy of the Oakland Fire Department.)

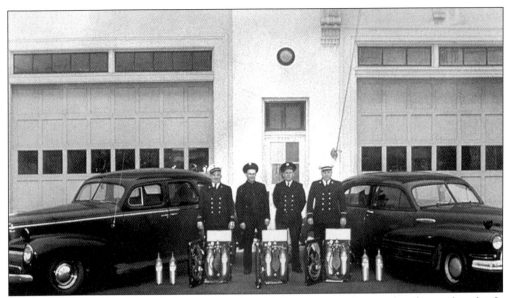

Battalion chiefs 5 and 6 and their respective chief's operators (men who drove the chief's "buggies" and assisted them at emergencies) pose in front of Engine Company No. 8, Truck Company No. 5, and Battalion No. 6's new quarters at 463 Fifty-first Street in North Oakland in 1953. They are proudly showing off the latest medical equipment carried by OFD battalion chiefs at that time—portable oxygen bottles called "inhalators." (Courtesy of the Oakland Fire Department.)

Hoseman Don Matthews, one of the "King's Men" of Station No. 1, polishes the chrome on "the Whale" in 1954. "The Whale" was given its nickname by the men who had to drive this ungainly looking and unwieldy fire engine through the streets of downtown Oakland from 1940 until it was sold in 1965. (Courtesy of the Oakland Library.)

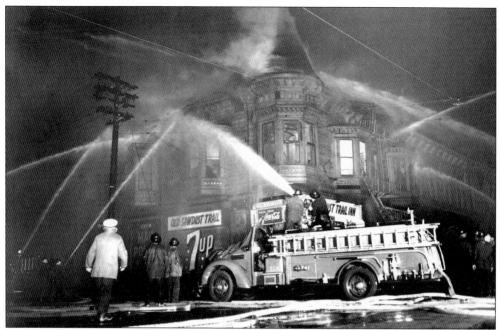

A fire ripped through the Sawdust Trail Inn on January 14 and 15, 1949. Built during the Victorian era, the Sawdust Trail was an ornate hotel that took up most of a city block. Early on, the fire took control of the common attic and soon warranted six-alarms, bringing most of Oakland's on-duty force to the scene. Ladder pipes and deck guns can be observed pouring water on the flames while the fire continues to grow in size and intensity. Oakland firefighters were kept busy until well into the following morning. (Courtesy of the Oakland Fire Department.)

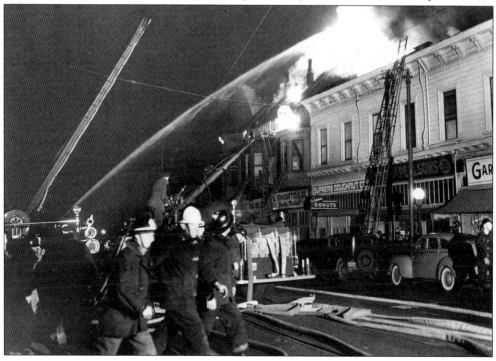

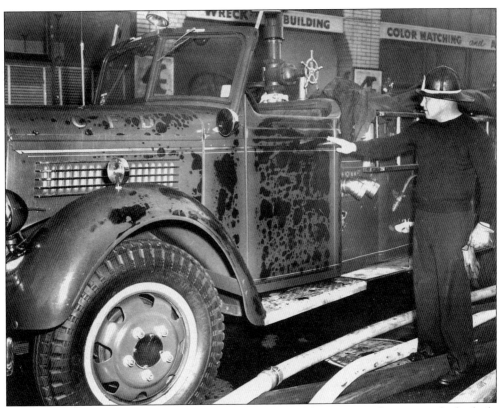

A new paint job is in store for this unidentified Oakland hose wagon that was parked a little too close to the flames. (Courtesy of the Oakland Fire Department.)

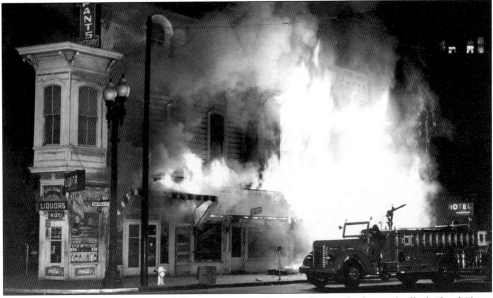

Hose Wagon Company No. 15 brings in two three-inch supply lines (called "leads") to this Victorian-era taxpayer fire on San Pablo Avenue, c. 1950. (Courtesy of the Oakland Fire Department.)

Smoke billows skyward as a fire takes control of a large commercial building in the 1950s. Two firemen from an Oakland truck company can be seen laddering an adjacent building in order to protect it from the encroaching flames. (Courtesy of the Oakland Fire Department.)

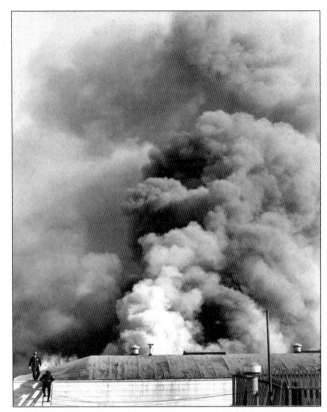

Four determined-looking Oakland enginemen battle a stubborn blaze with the "big line," a heavy 2½-inch hose used for large fires. Pictured here in 1950 are Hosemen Copelan and Cummings, Lieutenant Zollner, and Hoseman Reese. (Courtesy of the Oakland Fire Department.)

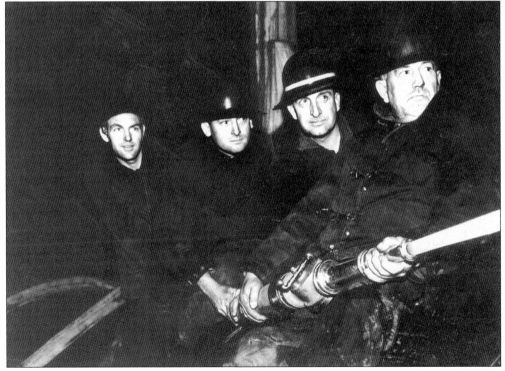

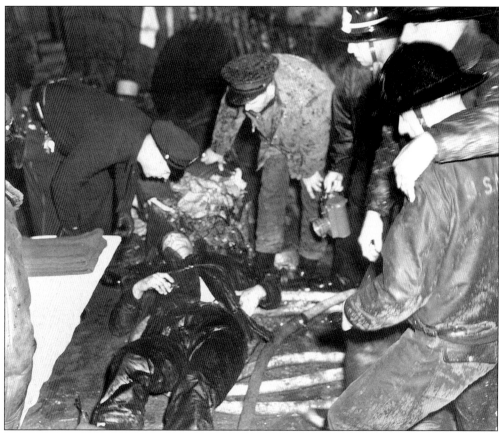

Hoseman Clyde Langlois of Engine Company No. 1 lays badly injured after making an aggressive interior attack at a working fire in downtown Oakland on Christmas Day, 1950. Many firefighters suffered from smoke inhalation during their careers prior to the introduction of the self-contained breathing apparatus, more commonly referred to as the SCBA. The SCBA was not widely used by the OFD until the early 1970s and was looked upon with disdain by many of Oakland's tough "smoke eaters." Fortunately, the SCBA has gained wide acceptance among today's firefighters and enables them to operate more safely in an extremely harsh environment. (Courtesy of the Oakland Fire Department.)

The Oakland Civil Defense and Disaster Organization compiled this list of emergency telephone numbers for the citizens of Oakland, c. 1950. (Courtesy of the Oakland Fire Department.)

The men of Truck Company No. 6 extend a straight ladder off the end of an extension ladder in this 1950 photograph. A difficult and dangerous maneuver, extending a ladder with a ladder has been practiced by many Oakland new kids, but has rarely been used on the fire ground. (Courtesy of the Oakland Fire Department.)

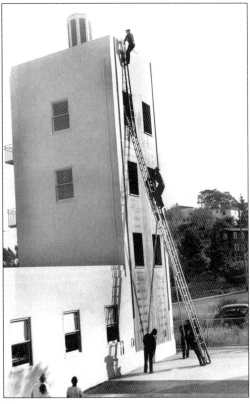

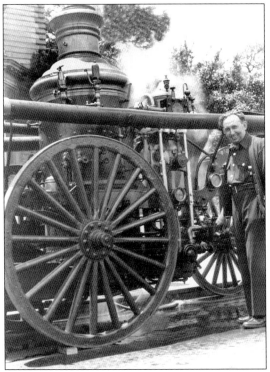

Lt. Clancy Crum of Engine Company No. 4 is all smiles as he operates the controls of this old steam fire engine in Oakland on May 30, 1952. Crum, whose father had been a fireman in Oakland, was the last member of the OFD certified to operate steam fire engines. This very steamer, all brass, chrome, and gold leaf, can be seen today proudly on display at the Oakland Museum of California, thanks in large part to Clancy's efforts to preserve this beautiful piece of OFD heritage. (Courtesy of the Oakland Fire Department.)

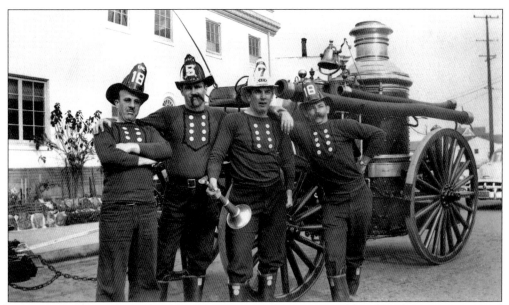

Dressed in 1880s garb, four Oakland firemen stand next to an old Oakland steam engine and take a step back in time in this 1951 photograph. Pictured here, from left to right, are A. Barr, R. Griffin, E. Nunes, and H. March. (Courtesy of the Oakland Fire Department.)

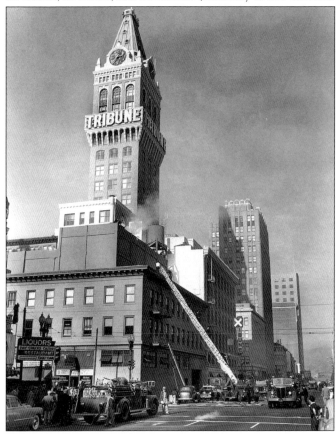

In this January 31, 1954 photograph, the firemen of the 2nd Battalion quickly bring a small fire on the roof of the *Oakland Tribune* building under control. (Courtesy of the Oakland Fire Department.)

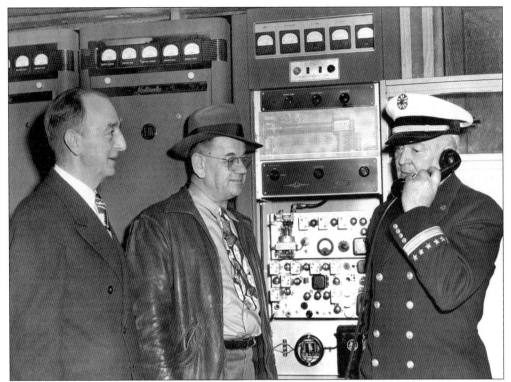

Fire Chief James Burke demonstrates the 250-watt transmitter for the Oakland Fire Department's new two-way radio telephone system installed on the 11th floor of city hall in 1953. (Courtesy of the *Oakland Tribune*.)

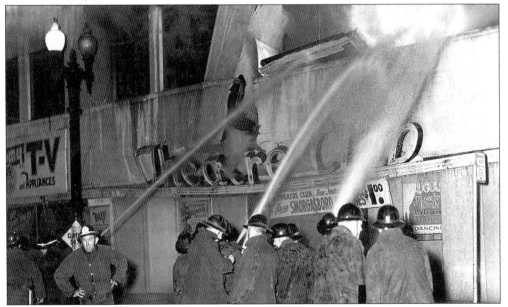

Oakland firemen direct hose streams into the doomed Theatre Club on April 23, 1952. Fire can be seen venting into the night sky as the restaurant's roof begins to fail. (Courtesy of the Oakland Fire Department.)

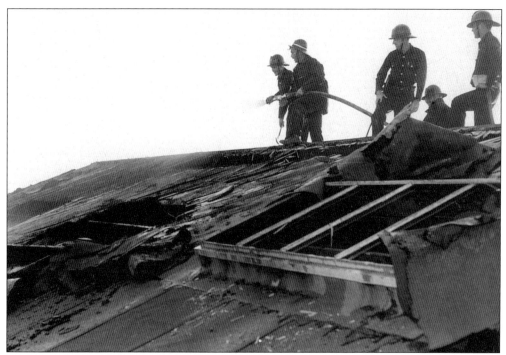

Members of this Oakland truck company admire their handiwork on the roof of a warehouse at the Oakland Army Base, c. 1947. Having cut a ventilation hole and broken out a skylight, they now concentrate on cooling down hot spots. (Courtesy of the Oakland Fire Department.)

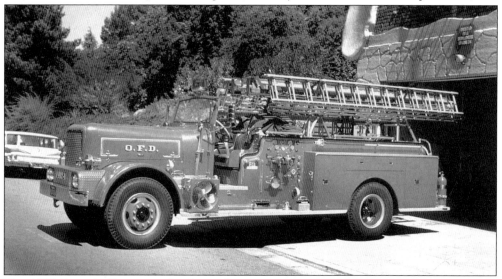

This 1955 Coast 1250-gpm quadruple combination pumper served as Engine Company No. 24 in Oakland's prestigious and far-removed Montclair Village from 1955 until 1981. The only "quad" in the OFD, it carried a hose, a pump, water, and 146 feet of ground ladders. The quad also had chain saws, smoke ejectors, and salvage equipment. If it was sent to a fire and was assigned as the first due company, it would operate as an engine; otherwise, it would operate as a truck company. This dual-role apparatus gave the Oakland hills a much-needed truck company. (Courtesy of the Oakland Fire Department.)

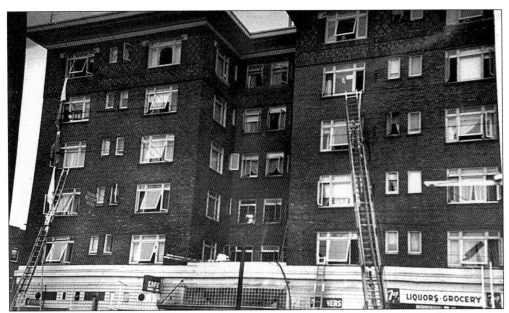

The Oakland Fire Department gained national fame when 91 people were rescued with aerial and ground ladders in the early morning hours of September 24, 1951. The fire at the Oakland Court Apartments started near the first floor stairway, and quickly spread to the upper floors. Engine Company No. 1, returning from another alarm, passed the building just as the fire was discovered and hastily stretched a big line up the stairway to protect fleeing civilians. First responding companies discovered victims in every window. Hoseman Barney Walsh was given the "Man of the Year" award by the OFD brass for his daring rescue of a man who jumped into his arms just as Walsh was reaching the top of Truck Company No. 4's aerial ladder. (Courtesy of the Oakland Fire Department.)

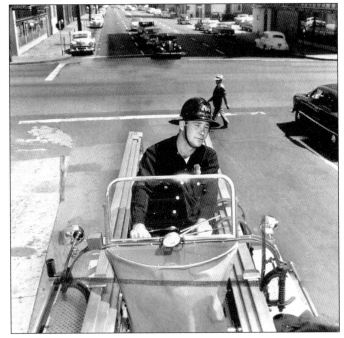

Sitting in the "bucket" (a bathtub-like seat perched on the rear of a fire truck) 10 feet above the sidewalk, this tillerman had an excellent view of the street below in this 1953 photograph. Tillered fire trucks are much more maneuverable than most fire engines; the truck driver and the tillerman work together by steering both the front and back end of the truck through tight spaces. Today, all seven of the OFD's truck companies continue to use tillered fire apparatus. (Courtesy of the Oakland Library.)

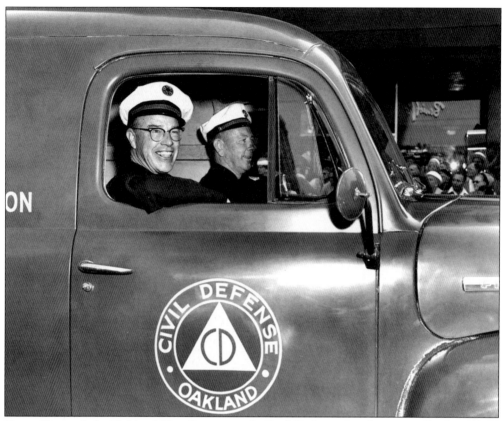

Two officers of the Oakland Fire Department's Civil Defense Auxiliary proudly drive their command vehicle in a parade through downtown Oakland in the early 1950s. (Courtesy of the Oakland Fire Department.)

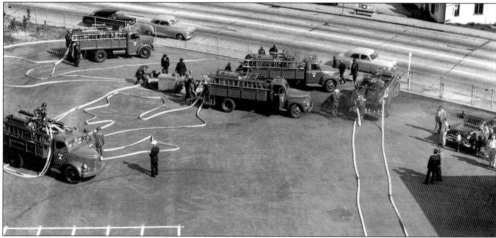

This February 13, 1955 drill of the Oakland Fire Department's Civil Defense Auxiliary (CDA) was held at the training division, located then at Forty-eighth Avenue and MacArthur Boulevard. The CDA was a volunteer emergency force meant to augment the OFD in the event of a nuclear or natural disaster. It was organized in 1950 under the direction of the OFD's Captain Rehor and disbanded in 1956. (Courtesy of the Oakland Fire Department.)

Wielding axes and hoses, men of the OFD's Civil Defense Auxiliary drill at an abandoned building at Fifth and Oak Streets on March 9th, 1952. (Courtesy of the Oakland Fire Department.)

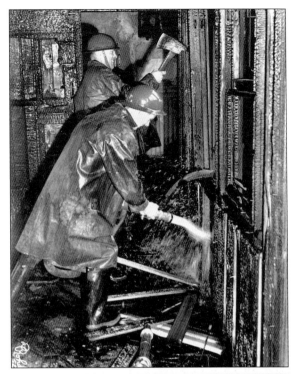

During the 1950s, it proved easier to integrate on the basketball court than in the firehouses of the OFD. Pictured here are the members of the OFD basketball team in 1954. Future chief of the Oakland Fire Department Godwin Taylor is kneeling in the center, front row. (Courtesy of Eric Logan.)

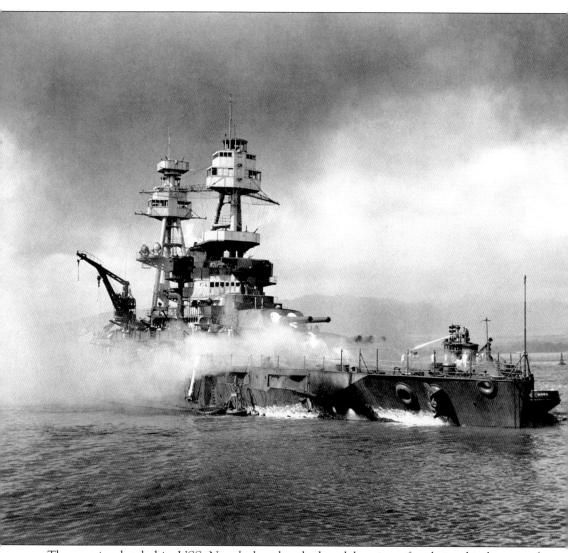

The massive battleship USS *Nevada* lays beached and burning after being hit by several Japanese bombs and torpedoes at Hospital Point in Pearl Harbor. The harbor tug USS *Hoga* is alongside the *Nevada*'s port bow, helping to fight fires on the battleship's forecastle on the morning of December 7, 1941. (Courtesy of the National Archives.)

Five
THE FIREBOAT (1948–2003)

In 1948, the City and Port of Oakland were able to acquire, for the meager sum of $1 per year, a slightly worn U.S. Navy tugboat. This vessel, the former USS *Hoga* (YT-146), would protect Oakland's waterfront for almost 45 years as the OFD's first fireboat. Prior to its lease by the City and Port of Oakland, the *Hoga* had served the Navy as a yard tug at Pearl Harbor Naval Station. She was there on that fateful Sunday of December 7, 1941, when the Imperial Japanese Navy carried out its devastating surprise attack on the unsuspecting U.S. Pacific Fleet. The USS *Hoga* sprang into action even as the first enemy bombs and torpedoes struck huge battleships, and she continued operating non-stop until the following Wednesday, fighting fires on numerous ships and rescuing many sailors from Pearl's oily waters. She was able to save the repair ship USS *Vestal* from certain destruction by pulling her away from the doomed battleship USS *Arizona*, which Japanese bombs had turned into an inferno.

The *Hoga*'s greatest feat came late in the attack when the only battleship to get underway, the USS *Nevada*, was able to limp towards the open sea. The *Nevada*, though heavily damaged from several bomb and torpedo hits, was barely making way and in danger of sinking while she attempted to escape the Japanese onslaught. It was then that she drew the attention of more than 20 Japanese aircraft. Had they succeeded in sinking the *Nevada* while she was in the narrow channel leading to the Pacific, she would have become a "cork in a bottle," making it impossible for any other ship to get in or out of Pearl Harbor. Had the *Nevada* been sunk there, the outcome of the war in the Pacific would have been much different. Thankfully, the *Hoga* and her 11-man crew were able to come to the *Nevada*'s aid and ground her at Hospital Point before the Japanese were able to sink her. For her extraordinary work on that day of infamy, the USS *Hoga* and her crew received a special unit citation from Adm. Chester Nimitz.

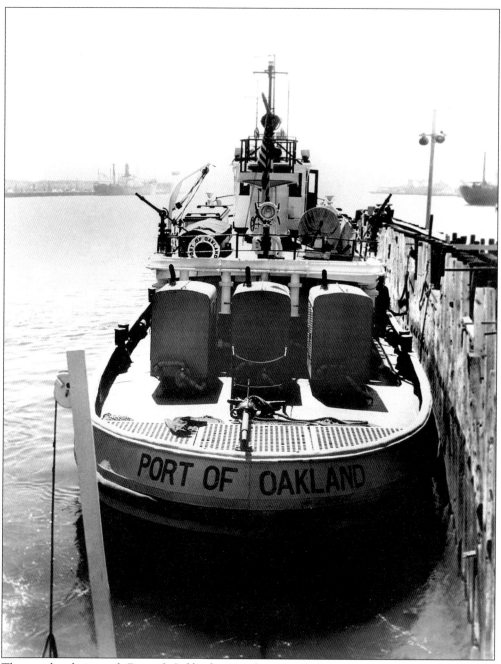

The newly christened *Port of Oakland*, once known as the USS *Hoga*, was modified in November of 1949 when three 2,000-gpm centrifugal pumps were installed on the aft main deck, each powered by its own diesel engine. (Courtesy of the Oakland Fire Department.)

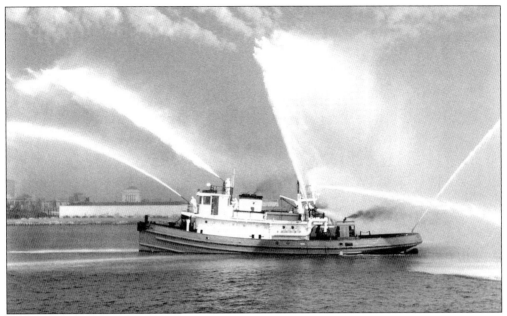

The *Port of Oakland* steams across the Oakland Estuary with all of her turrets firing. When originally built, the USS *Hoga* was able to pump 4,000 gpm. After her modification in 1949, the *Port of Oakland*'s pumping capability was boosted to an impressive 10,000 gpm. (Courtesy of the Oakland Fire Department.)

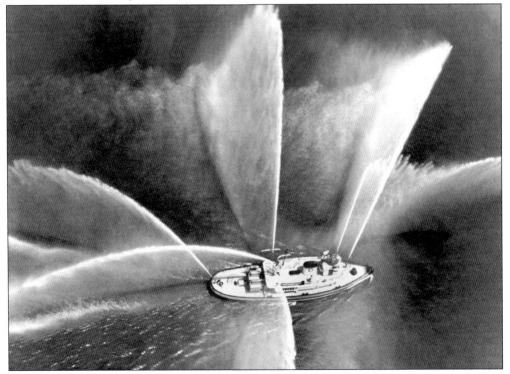

This unique overhead photograph shows the *Port of Oakland* and her amazing capabilities from an entirely different perspective. (Courtesy of the Oakland Fire Department.)

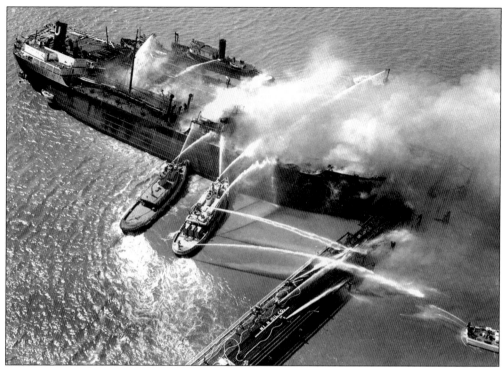

A total of seven fireboats, among them the *Port of Oakland*, came to the aid of a stricken oil tanker burning out of control at the refineries near Martinez. The *Port of Oakland* directed her powerful streams amid ships on the tanker as well as onto the pier, which had also caught fire. (Courtesy of the Oakland Fire Department.)

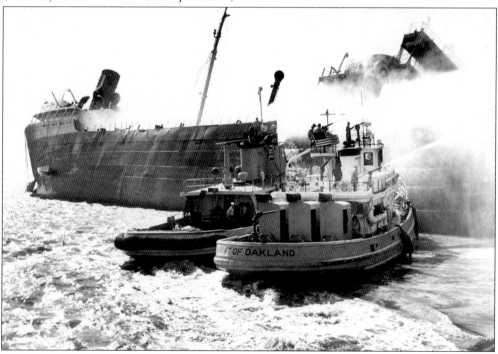

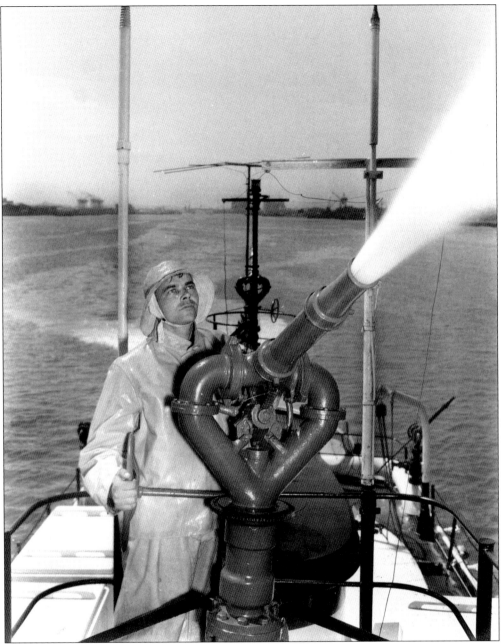

This powerful turret set on a platform atop the *Port of Oakland*'s superstructure was capable of delivering 2,000 gpm. Her crew donned foul-weather gear when operating these massive water cannons. (Courtesy of the Oakland Fire Department.)

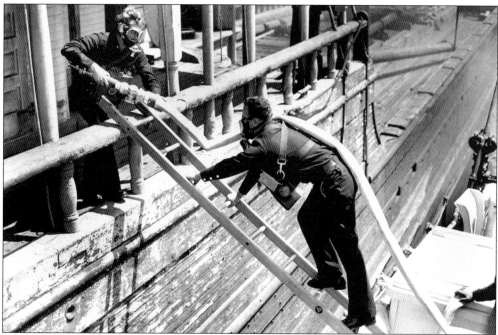

Two firemen advance a hose line up a ladder from the *Port of Oakland* onto the main deck of a burning freighter, c. 1949. The men are wearing U.S. Navy-issued SCBAs known as "OBA" (oxygen breathing apparatus). The OBA utilized a canister of pure oxygen, which was strapped to the user's chest. Exhaled air was then recirculated, giving each canister about an hours worth of use. (Courtesy of the *Oakland Tribune*.)

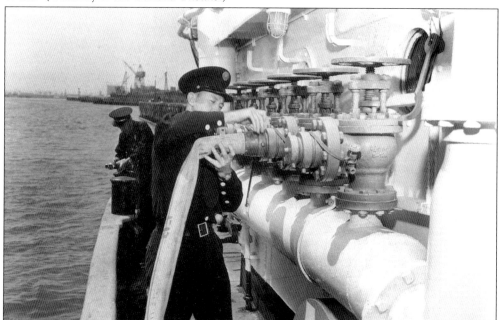

A *Port of Oakland* crewman connects a fire hose to one of the boat's 12 three-inch gated outlets. Visible above his head is the exposure protection spray system, which kept both the men and the boat cool when operating near burning ships and piers. (Courtesy of the *Oakland Tribune*.)

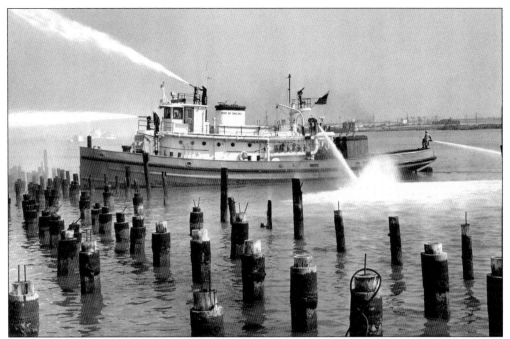

Powered by two Westinghouse 515-horsepower diesel-electric motors that turned a single-screw propeller, the metal-hulled *Port of Oakland* was capable of an impressive 16 knots. She was 99 feet long and had a beam of 27 feet. Her pumps fed a total of 7 turrets located strategically throughout the vessel. (Courtesy of the Oakland Fire Department.)

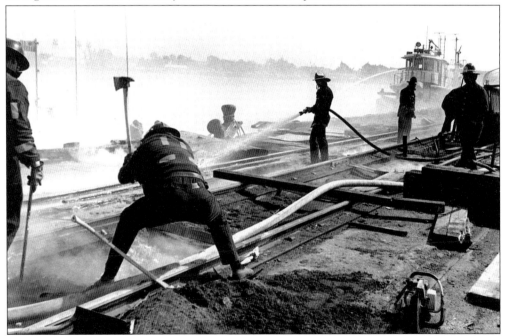

The *Port of Oakland* can be seen in the background dousing hot spots with her forward turret as firemen from land-based companies continue to mop up after a stubborn pier fire on April 15, 1970. (Courtesy of the Oakland Fire Department.)

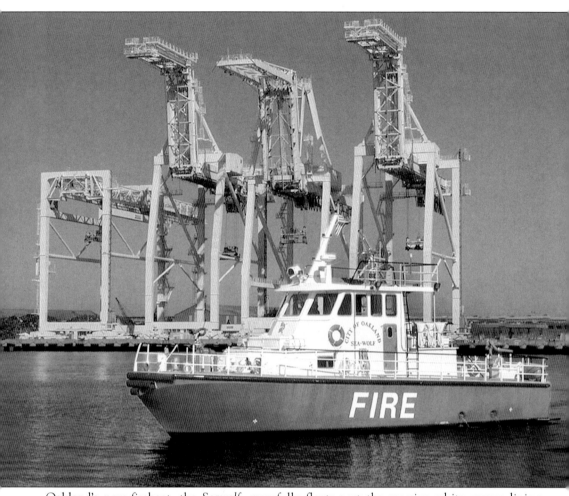

Oakland's new fireboat, the *Seawolf*, gracefully floats past the massive white cranes lining the *Port of Oakland*, c. 1995. Named after a novel by Oakland author Jack London, the *Seawolf* was put into service on September 20, 1994. She replaced the venerable *Port of Oakland*, which faithfully served the OFD for 45 years. (Courtesy of the Oakland Fire Department.)

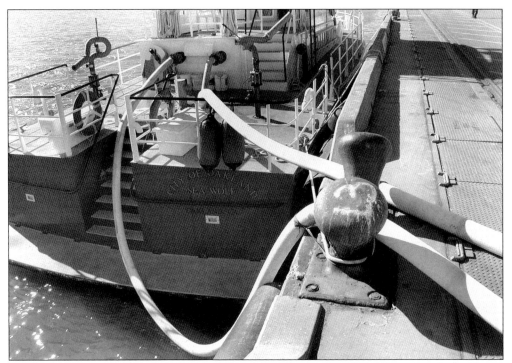

The *Seawolf* was purchased with Bond Measure I funds after the devastating Loma Prieta Earthquake of 1989. Her mission was to protect Oakland's valuable port and waterfront area. She was capable of pumping 7,500 gpm from her four turrets. She could also provide water to four portable water supply system (PWSS) hose wagons, which were purchased with the same bond funds. (Courtesy of the Oakland Fire Department.)

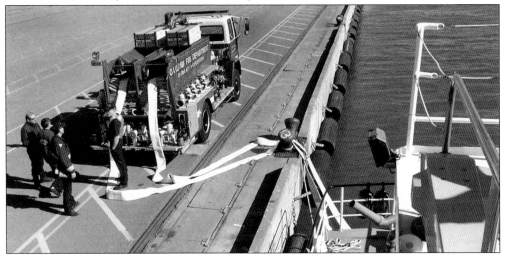

The PWSS hose wagons each carried one mile of five-inch hose, pressure-reducing Gleason valves, and hose bridges. If an earthquake destroyed Oakland's fire main, the *Seawolf* could draft 7,500 gpm to an aboveground portable hydrant system set up by the PWSS hose wagons in order to protect downtown. Unfortunately, due to budget cuts, Engine Company No. 2, which staffed the *Seawolf* with specially trained fireboat personnel, closed in 2003. (Courtesy of the Oakland Fire Department.)

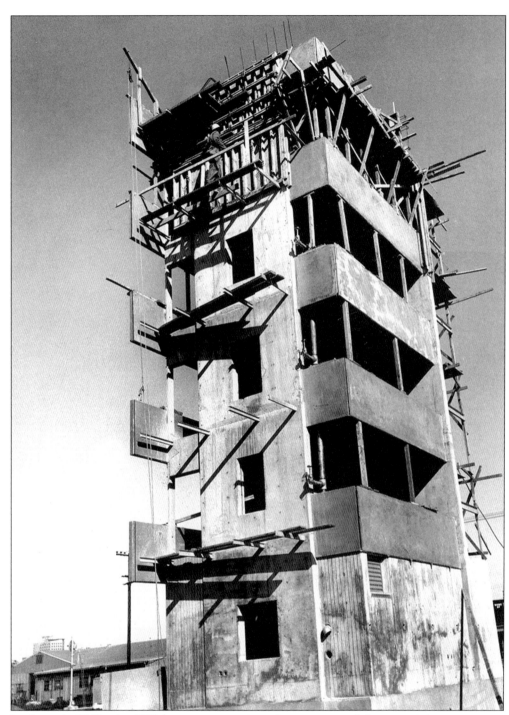

In the early 1960s, the OFD began construction of a new state-of-the-art training tower next to the Oakland Estuary. The tower was equipped with standpipes, a fire escape, and a special room used for live-fire training. Known by new recruits and salty veterans, the "Drill Tower" has played a major role in developing civilians into Oakland firefighters for over 40 years. (Courtesy of Eric Logan.)

Six
THE OAKLAND FIRE DEPARTMENT EVOLVES

The Oakland Fire Department went through a massive reorganization in the early 1960s. With the help of a local bond measure, 13 new fire houses (Engine Company Nos. 5, 6, 9, 12, 13, 15, 16, 17, 19, 21, 23, 27, and 31) were constructed in Oakland between 1960 and 1964. These modern fire stations replaced many older ones that had at one time housed men and horses of the OFD. Three Oakland engine companies were relocated from the flatlands to the Oakland hills to provide better fire protection for growing residential areas. A new drill tower was also constructed during this period.

During this decade, older gasoline-powered fire engines and trucks were replaced with safer, more efficient diesel apparatus. In 1962, the OFD purchased a unique aerial apparatus called the Pitman Snorkel, which had an articulating boom with a platform attached to the tip that was able to reach places traditional aerial ladders couldn't. These new and improved fire apparatus were able to rapidly traverse their way across town using a new system of roads called "freeways," five of which ran through Oakland.

A landmark change in working conditions for members of the OFD occurred in the early 1960s with the introduction of the three-platoon system and the 56-hour workweek. This change was largely due to the diligent efforts of the officers of the IAFF Local No. 55. For the first time in the history of the OFD, there was now a C shift, marking a significant departure from the old system of working 24 hours, followed by 24 hours off.

Although African-American and white firefighters integrated in 1955, it wasn't until 1972 that the first Asian-American firefighter was hired by the OFD. Eight years later, the OFD hired its first woman firefighter. On May 1, 1981, that long process of integration culminated in the appointment of Samuel Golden, an African American, as chief of the OFD. Chief Golden had started his career as a hoseman at segregated Engine Company No. 22 many years before.

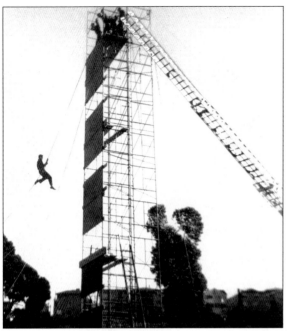

During Fire Prevention Week in October 1959, the OFD put on many demonstrations around Lake Merritt, including this daring rappel maneuver off a tower made of scaffolding. (Courtesy of the Oakland Fire Department.)

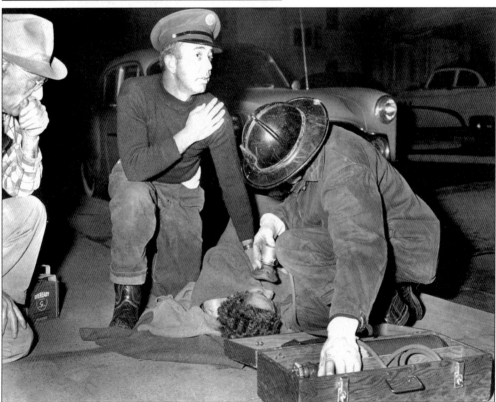

A civilian suffering from smoke inhalation at a house fire at 509 Forty-first Street was given oxygen by two unidentified Oakland firemen after she was rescued, while a bystander looked on in 1957. (Courtesy of the Oakland Fire Department.)

A racially integrated Oakland engine company, led by an African-American officer, fights a fire at the East Bay Sanitary Rag Works, located at 2601 Adeline Street in October 1959. Prior to 1955, Oakland kept its firefighters segregated. (Courtesy of the Oakland Fire Department.)

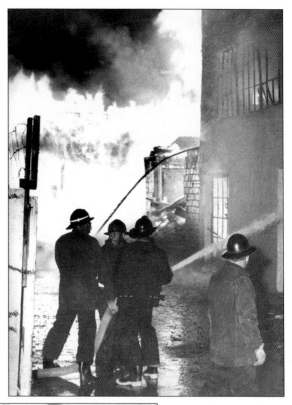

It was three strikes for Fireman Don Dietz of Engine Company No. 21, as Fireman Al Wood, playing catcher, smiles in the background. The caption on this photo reads, "No runs, no hits, no balls, no errors, May 2nd, 1961." (Courtesy of the Oakland Fire Department.)

Engine Company No. 21 was relocated to 13150 Skyline Boulevard in the Oakland hills in May 1961. The OFD underwent a massive reorganization in the early 1960s in order to meet Oakland's growing needs. During this time, 13 modern firehouses were built to replace many that had been built for horse-drawn apparatus. Oakland Engine Companies Nos. 6, 17, and 21, were relocated to the Oakland Hills to protect new residential neighborhoods. (Courtesy of the Oakland Fire Department.)

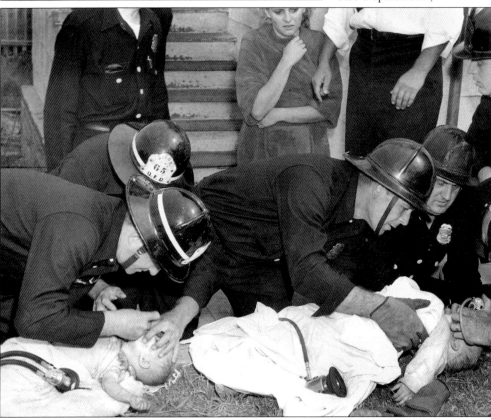

An anxious mother watches as several Oakland firemen try to save her two young children following a house fire in 1960. The children are suffering not from burns, but from smoke inhalation. Many more people die each year in the United States from smoke inhalation than from burns. The author was unable to learn the fate of these two children. (Courtesy of the Oakland Fire Department.)

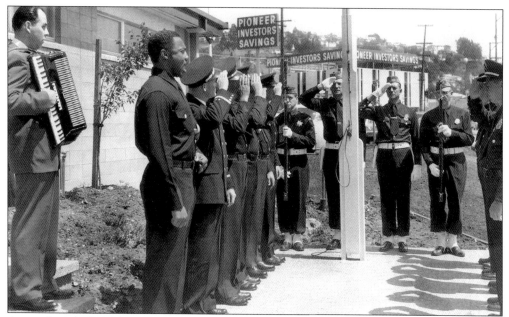

An unidentified Oakland fireman stands before an honor guard and sings the national anthem, accompanied by the accordion, during the dedication of Engine Company No. 23 and Truck Company No. 8's new quarters on April 25th, 1962. (Courtesy of the Oakland Fire Department.)

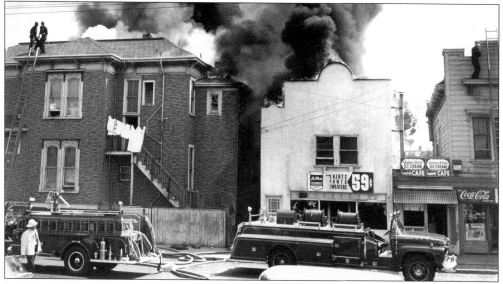

Fire extends into adjacent buildings at Fourteenth and Linden Streets as the members of Engine Company No. 32 begin their interior attack in this 1960 photograph. When Chemical Company No. 1 was disbanded in 1948, Engine Company No. 32 was organized in its place. Engine Company No. 32 became the elite unit in the OFD, staffed with smart, aggressive, young firemen. Engine Company No. 32 was quartered with Engine Company No. 1 and was sent on all downtown box alarms, as well as any working fire west of Fruitvale Avenue. After 29 years of service, Engine Company No. 32 was disbanded on March 19, 1977, due to budget cuts. (Courtesy of the Oakland Fire Department.)

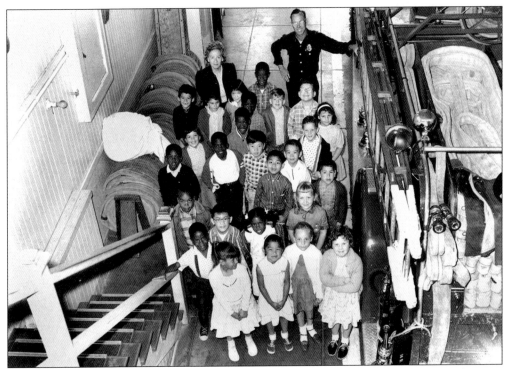

Miss Florence Rosen's first-grade class from Bella Vista Elementary School took a tour of Engine 16's quarters on April 20, 1961. The faces of these children reflect the growing racial diversity found throughout the neighborhoods of Oakland. (Courtesy of the Oakland Fire Department.)

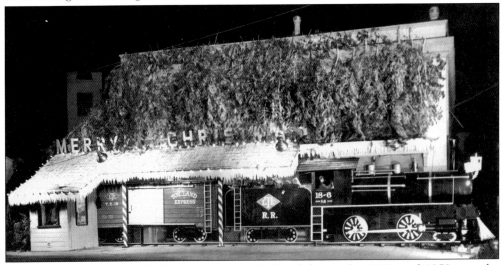

A popular winter activity for families living in Oakland during the 1940s and 1950s was the Oakland Fire Department's annual Operation Christmas. Every December, all OFD companies would decorate their firehouses with elaborate dioramas, nativity scenes, or animated models. In the evenings, families would pile into their cars and take a drive through Oakland and vote for the company that had the best holiday spirit. Pictured here is Engine Company No. 18 and Truck Company No. 6's quarters in December 1952. (Courtesy of the Oakland Fire Department.)

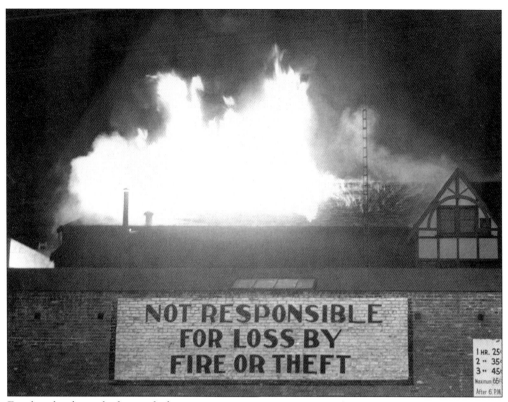

Fire breaks through the roof of Ebell Hall on Fifteenth and Harrison Streets on November 9, 1959. The sign painted on the wall of a nearby parking lot adds irony to the destruction behind it. The building was a total loss. (Courtesy of the Oakland Fire Department.)

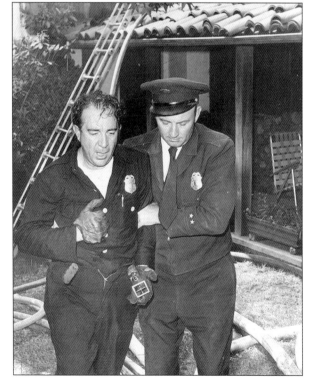

Chief's Operator Herb Spence, in this dramatic, c. 1960 photograph, assists Hoseman Will Pavon from the scene of a house fire. At the time, many Oakland firemen fought with very little protective clothing. These brave men would go into a burning building wearing nothing more than a fiberglass helmet, leather gloves, and a "tanker" jacket made of heavy cotton. (Courtesy of the Oakland Fire Department.)

The East Bay Producers Milk Council got a red-hot endorsement from the men of Engine Company No. 32 in this publicity photo taken in the early 1960s. The ad's caption read, "After the Oakland Fire Department quenches the fire, Milk quenches the thirst!" (Courtesy of the Oakland Fire Department.)

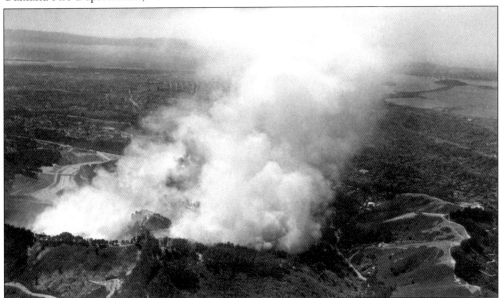

A huge column of smoke rises into the air from the "Fish Ranch Road Fire" on September 22, 1970. The fire started on Marlborough Terrace and Norfolk Road and soon went to a general alarm. The OFD requested mutual aid for the first time in 30 years and fire departments from Fairfield to Milpitas responded to Oakland's call for help. (Courtesy of the Oakland Fire Department.)

Battalion Chief Hyatt Bunn's face is lined with worry as he directs the fight during the Fish Ranch Road Fire. This fire tested the mettle of the OFD and stretched its resources to the breaking point. Thirty-seven homes were completely destroyed and another 17 were partially consumed by the flames. As big as the Fish Ranch Road Fire was, it was dwarfed by a fire that would occur in the same area 21 years later. (Courtesy of the Oakland Fire Department.)

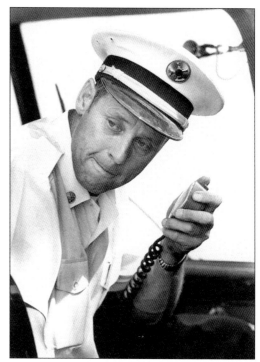

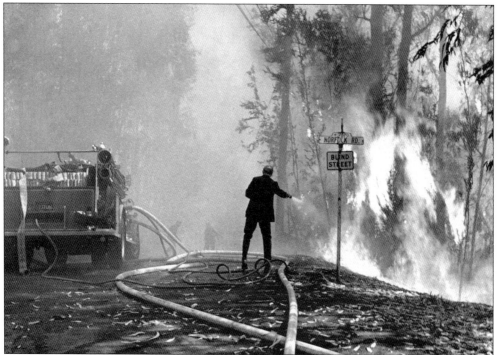

A civilian in dress suit on Norfolk Road valiantly makes a stand alongside an Oakland engine company during the Fish Ranch Road Fire on September 22, 1970. Many civilians rushed to the scene to help fight the fire and were put to work by overwhelmed firefighters. (Courtesy of the *Oakland Tribune*.)

The crew of Truck Company No. 1 stands proudly in 1972. From left to right are Firemen Steve Baptista, Al Wraa, John Buckhorn, Dick Cecil, and their lieutenant, Bill Elliott, who died in the line of duty seven years later in the smoke-filled Trans-Bay Tube. (Courtesy of Al Wraa.)

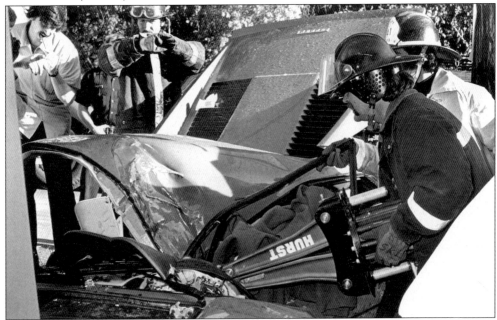

Using the "jaws of life," Fireman Janowski of Truck Company No. 6 works to free the trapped driver of this Ferrari with the assistance of Captain Garcia, c. 1979. Fireman DeGlymes watches in the background. These new tools were first put in service by Oakland in the late 1970s. Used for auto extrication, they are capable of generating incredible force using hydraulics. Hurst tools are carried on all OFD truck companies and the heavy rescue company. (Courtesy of Victor Loverro.)

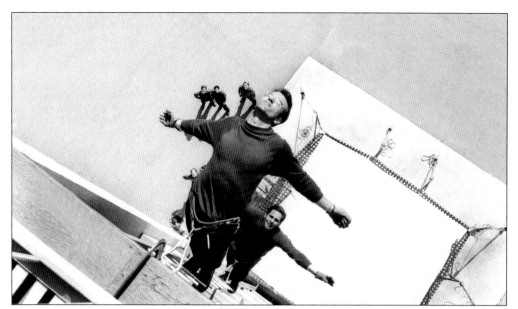

In 1972, the recruits of Group V began their training at the OFD drill tower. Roy Chin was in this recruit class and was the first Asian American to be hired by the OFD. Fittingly, Roy was given the nickname, "Number One." Here, Roy's classmates Andy Papp (top) and Bob Guzy learn to trust their equipment while hanging off pompier ladders. (Courtesy of the Oakland Fire Department.)

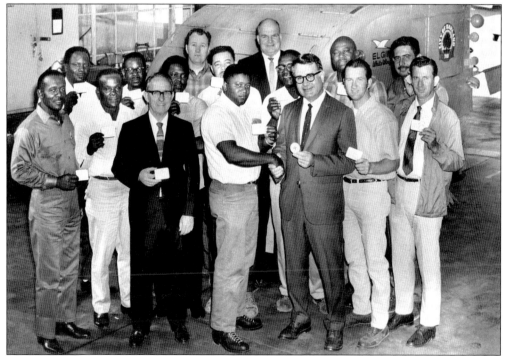

The mechanics of Oakland's heavy equipment shop show off their new first-aid cards after the American Red Cross certified them all in the early 1970s. (Courtesy of the Oakland Fire Department.)

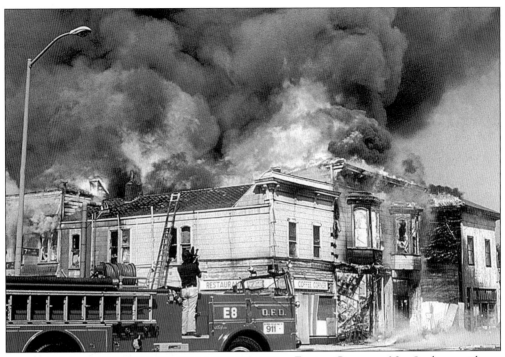

Engine Company No. 8, along with the companies of the OFD's 2nd, 5th, and 6th Battalions, battled a raging fire in five Victorian-era buildings that threatened to consume an entire city block in West Oakland in 1976. (Courtesy of Frank Wong.)

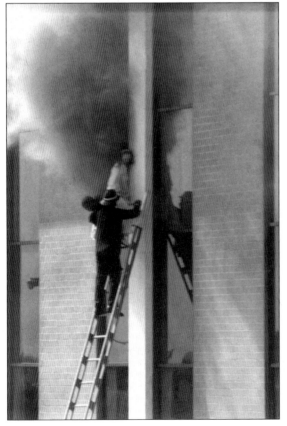

An officer from Truck Company No. 8 uses a ladder to rescue two civilians from the second floor of an office building on Church Street in East Oakland in 1975. The fire, set by an arsonist, killed a woman on the upper floors who was unable to escape the smoke and flames. (Courtesy of the Oakland Fire Department.)

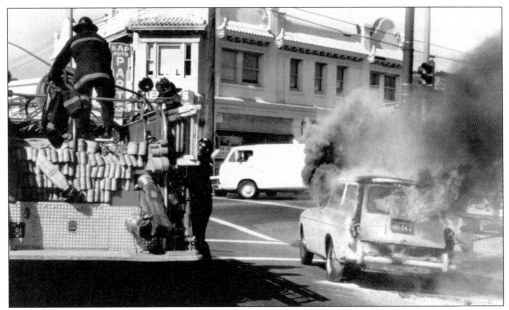

Engine Company No. 8 rolls up to a car fire at Alcatraz and Telegraph Avenue in 1975. A passing motorist tried unsuccessfully to extinguish the flames with a fire extinguisher before calling the fire department. (Courtesy of the Oakland Fire Department.)

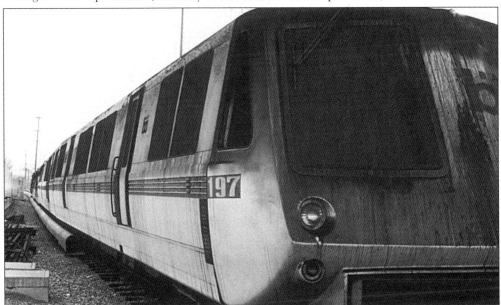

On January 17, 1979, the Oakland Fire Department was dispatched to the BART Trans-Bay Tube (a 3.6 mile-long subway tunnel lying on the bed of San Francisco Bay that links Oakland with San Francisco) for a "smoke problem" on one of their trains. First-arriving companies found a BART car on fire and many civilians needing to be rescued. After the civilians were all safely evacuated to a waiting train, OFD companies, with SCBA tanks running low, attempted to retreat back to Oakland through the center bore of the tunnel. Thick, black smoke quickly overcame the firefighters, killing Lt. Bill Elliott of Truck Company No. 1, while 43 others were sent to the hospital. (Courtesy of the Oakland Fire Department.)

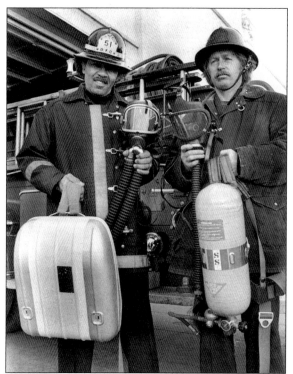

After Lieutenant Elliott perished in the Trans-Bay Tube, the BART system immediately purchased the new Draeger breathing apparatus. The "Draeger mask" was specifically designed for use underground and gave firefighters a better air supply than older, traditional SCBAs. In this photograph taken on January 25, 1979, Capt. Bill Boone Jr. of Truck Company No. 1 shows off the Draeger mask, while Fireman Carl Rasmussen holds onto an older SCBA. (Courtesy of the Oakland Fire Department.)

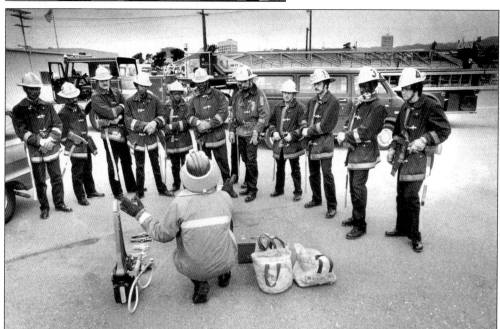

In February 1980, the OFD became one of the first fire departments in California to hire female firefighters. Shown here with their male counterparts are the first female recruits to be trained at Oakland's training division. Today, women comprise approximately 10 percent of the Oakland Fire Department and hold every rank from firefighter to battalion chief. (Courtesy of the Oakland Fire Department.)

Four members of Truck Company No. 2 narrowly manage to escape the flames venting from the fourth-story window of 1816 San Pablo Avenue in 1982 by climbing down an aerial ladder. The fire, which caused $500,000 in damage, went to five alarms before finally being brought under control. (Courtesy of Frank Wong.)

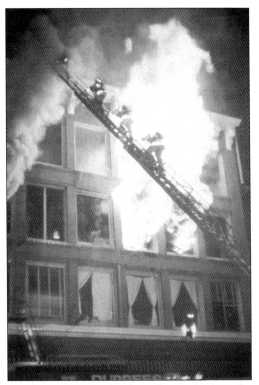

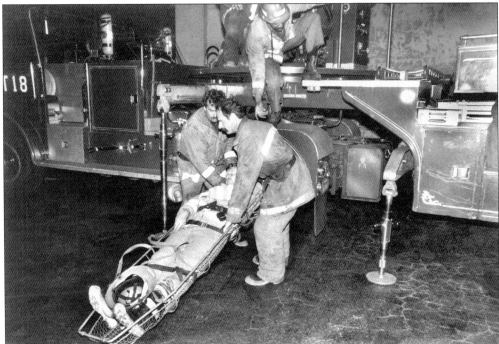

In this 1985 photograph, Firefighters Mike Ossana and Alex Matthews, both members of Truck Company No. 6, carry an injured Captain Wayne Schuette off the roof of the Bonanza Warehouse in a Stokes basket. (Bill Conduit photo; courtesy of the Oakland Fire Department.)

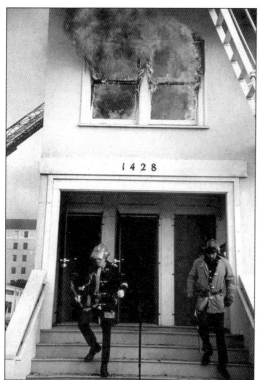

Truck Company No. 1 operated alone for several minutes after coming across a working fire in a downtown building in 1988. Fire rolls out of the second-floor window of 1428 Castro Street as Capt. Chris Heath and Firefighter Stan Killingsworth exit the building. The two performed a primary search of the first and second floors while waiting for additional companies to arrive. (Courtesy of the Oakland Fire Department.)

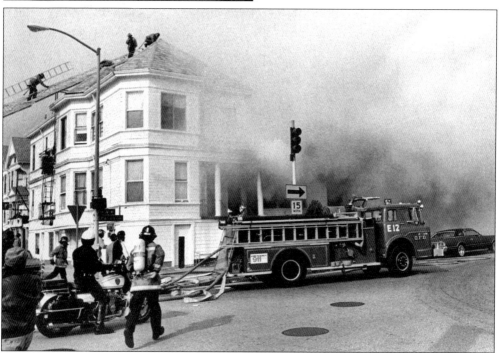

Engine Company No. 12 was first on the scene of this working fire in an apartment building in Chinatown in 1985. Several members of a truck company can be seen making their way to the roof, while additional firefighters rush in. (Courtesy of the *Oakland Tribune*.)

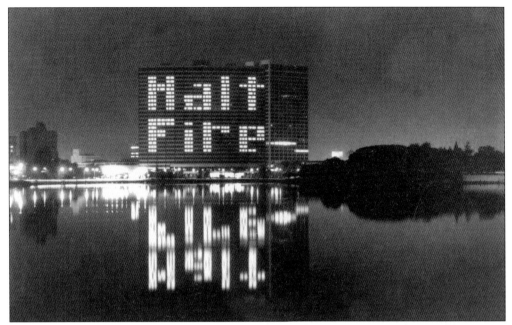

The immense Kaiser Building, located at 300 Lakeside Drive, spelled out this short safety message in huge letters to the citizens of Oakland during Fire Prevention Week, c. 1980. (Courtesy of the Oakland Fire Department.)

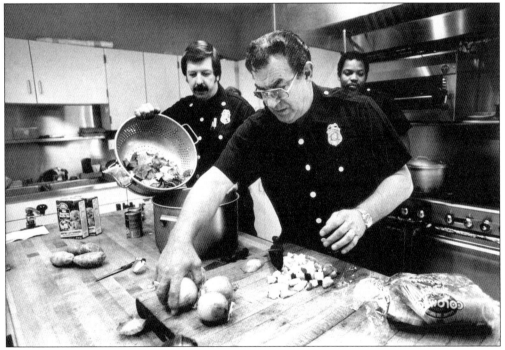

Firefighter Clifford Borges prepares the stuffing, while Lt. Jim Ready (left) and Firefighter Laforis Robinson (right) lend a hand in the kitchen of Station No. 1 on Thanksgiving Day 1983. The kitchen is the heart and soul of any Oakland firehouse and is a place where firefighters gather to tell stories, laugh, and share meals together. (Courtesy of the *Oakland Tribune*.)

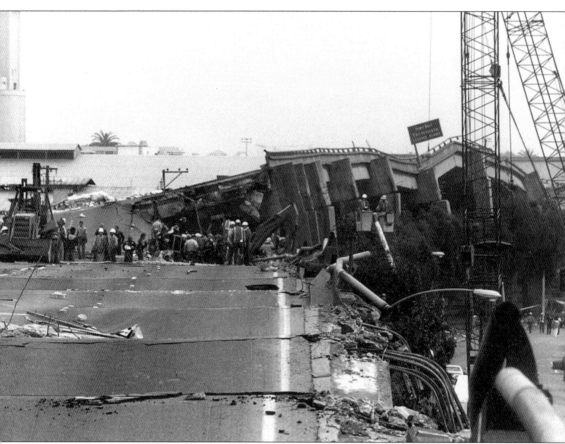

At 5:04 p.m. on October 17, 1989, the Bay Area was rattled by an earthquake that registered 7.1 on the Richter scale and caused widespread destruction. The "Loma Prieta Earthquake" was so powerful that it could be felt in an area over 400,000 square miles. Oakland was hard hit, with many buildings sustaining structural damage. Several large fires started as a result of ruptured gas lines. However, the most daunting challenge for the OFD that day was the collapse of the Cypress Freeway. (Courtesy of Gary Depp.)

Seven
MODERN DISASTERS

The men and women of the OFD have been challenged by several major disasters that have struck Oakland in the past three decades. Two of these disasters took place in the 1980s. The first occurred in the early morning of July 4, 1982, when a gasoline tanker collided with a bus inside the Caldecott Tunnel. The resulting fire killed seven people and kept firefighters at bay for many hours before finally being brought under control. The second major disaster to strike Oakland during this decade occurred on October 17, 1989, when the Bay Area was rocked by the 7.1 magnitude Loma Prieta Earthquake. The Cypress Freeway collapsed, trapping and killing many, while severed gas mains started fires throughout the city. Oakland firefighters and citizens alike performed many acts of individual heroism on that terrible day.

Two years later, Oakland was again struck by disaster, this time in the form of an urban firestorm. The fire began on the morning of October 20, 1991, and spread so rapidly that firefighters were unable to contain it. A synopsis of the Wildcat Fire in 1923, written by the National Board of Fire Underwriters, could have been about the "Tunnel Fire" 68 years later:

> *From the experience of the earlier stages of the fire, in which flying brands started new centers of conflagration blocks ahead of the burning building at which the firemen were working, it is the consensus of opinion of those at the fire, including chief officers and firemen, that had the wind not changed, the fire would have swept through the entire East Bay region.*

The horrific terrorist attacks on September 11, 2001, did not strike Oakland. This time the men and women of the OFD were able to come to the aid of their brother and sister firefighters of the Fire Department of New York in the form of the California Task Force 4, an urban search and rescue team based in Oakland. This USAR Team, comprised of many highly trained specialists, went on a ten-day deployment in October 2001 to assist in the recovery efforts in New York City.

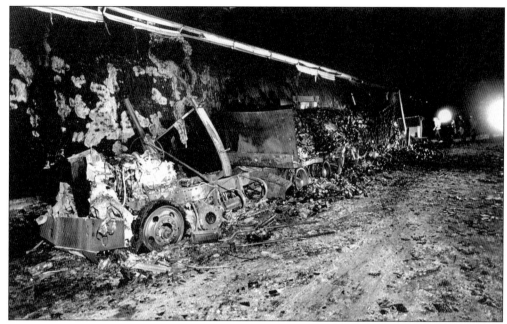

Just after midnight on July 4, 1982, a gasoline tanker collided with a bus and a car inside the Caldecott Tunnel on Oakland's Highway 24. The tunnel is over a half-mile long and connects Oakland with Orinda in Contra Costa County. The resulting fire ignited several thousand gallons of gasoline, making this one of the most challenging fires in the OFD's long history. (Courtesy of the *Oakland Tribune*.)

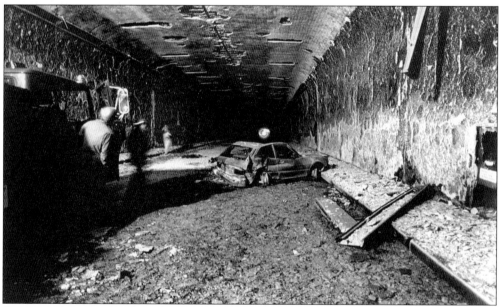

Seven civilians perished as they tried to escape the rapidly spreading inferno inside the Caldecott Tunnel. The OFD responded with seven engines, three trucks, and two battalion chiefs. It took their combined efforts and many hours of work before the fire was finally brought under control. Damage to the Caldecott Tunnel was in excess of $3 million. (Courtesy of the *Oakland Tribune*.)

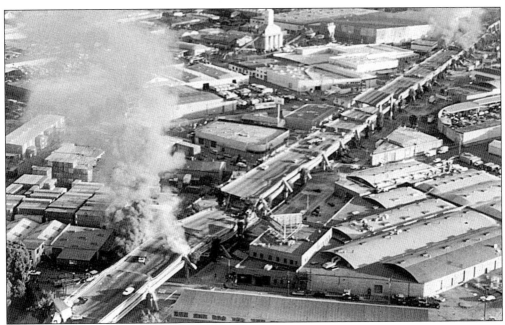

This overhead view of the collapsed Cypress Freeway shows the tremendous devastation wrought by the Loma Prieta Earthquake. First-arriving companies were confronted with a double-deck freeway that had collapsed, trapping or killing many drivers under tons of concrete and steel. Several crushed cars caught on fire and the smoke and flames threatened to kill those who were helplessly pinned in the debris. (Courtesy of the Oakland Fire Department.)

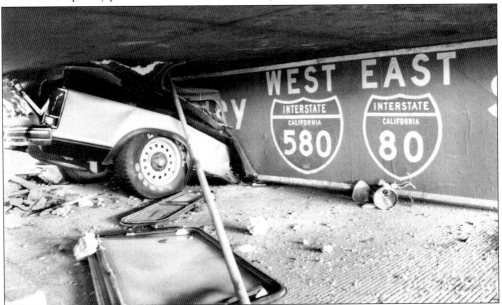

The Loma Prieta Earthquake killed 42 people and injured hundreds of others. The toll could have been much worse but for the first game of the World Series being played between the Oakland Athletics and the San Francisco Giants across the Bay at San Francisco's Candlestick Park. Many, who might have otherwise been out enjoying a beautiful afternoon, were instead at the game or watching it on television. (Courtesy of Gary Depp.)

On the morning of October 20, 1991, the hills of Oakland became a raging inferno when an ember from a fire the previous day was blown into some tinder-dry vegetation. Fanned by strong north winds, the fire quickly jumped the eight lanes of Highway 24. Within several hours, 25 people would perish in the flames, including Battalion Chief James Riley, who died attempting to rescue a civilian. This is a photograph of Chief Riley's helmet, which was recovered after the fire. (Courtesy of the Oakland Fire Department.)

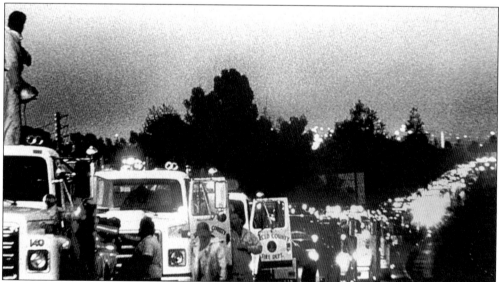

The "Tunnel Fire" of October 20, 1991, lasted three days, burned 1,580 acres, destroyed over 3,000 dwellings, killed 25 people, injured hundreds of others, and caused $1.68 billion in damage. At the height of the fire it is estimated that a home started to burn every 11 seconds. Over 500 fire engines from throughout the West responded to Oakland's plea for help. Pictured here are hundreds of fire engines awaiting assignments on Highway 13 on October 21, 1991. (Courtesy of the Oakland Fire Department.)

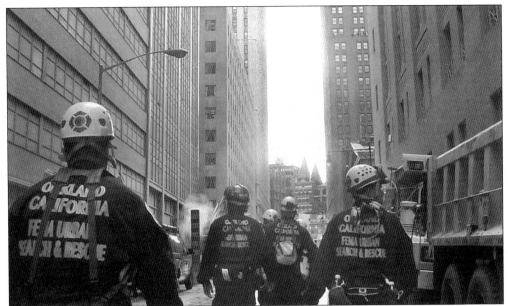

The 62 members of Oakland's Urban Search and Rescue Team (California Task Force 4) were activated following the terrorist attacks of September 11, 2001, that toppled the two World Trade Center towers. They arrived in Manhattan on October 23, 2001, and assisted the Fire Department of New York in recovery efforts. (Courtesy of the Oakland Fire Department.)

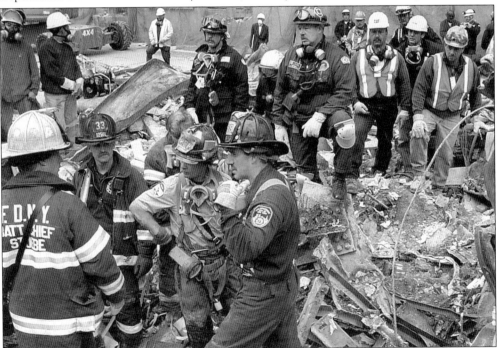

Oakland Task Force Leader Mark Hoffmann and fellow members of CATF-4 receive a briefing from an FDNY battalion chief at Ground Zero in late October 2001. The team worked 12-hour shifts and searched the rubble for human remains using fiber-optic cameras and specially trained dogs during its 10-day deployment to New York. (Courtesy of the Oakland Fire Department.)

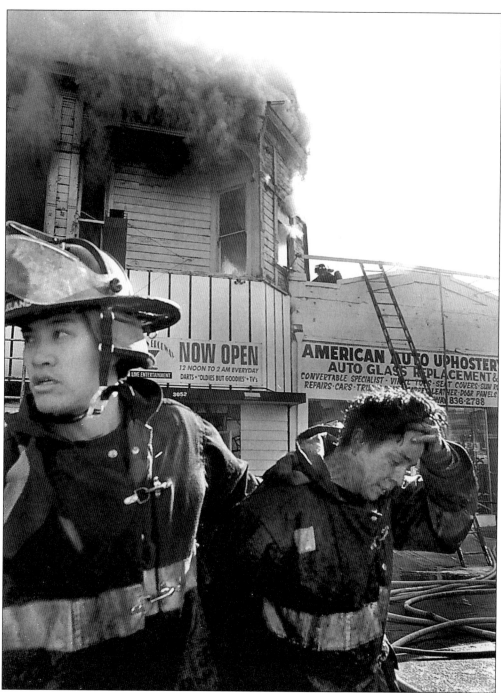

Injured Firefighter Sheree Rodriguez of Engine Company No. 12 is led to a waiting ambulance by Firefighter Damon Soo at the scene of a fire and collapse at the Back on Broadway Bar on January 10, 1999. Rodriguez and her officer, Lt. Kenny Van Gorder, were both pulled from the rubble by members of Truck Company No. 1 following the collapse. Tragically, fellow Oakland Firefighter Tracy Toomey was also buried in the collapse and succumbed to his injuries before he could be rescued. (Courtesy of Nick Lammers.)

Eight
THE OAKLAND FIRE DEPARTMENT TODAY

The Oakland Fire Department has gone through many transformations in the course of its 135-year history. Fire chiefs have come and gone. Companies have been formed, disbanded, and formed again. Units have been renumbered and relocated. Tools and equipment continue to change and improve. People of color and women now proudly wear the badge. In some ways, the OFD has become a microcosm for our society. The Oakland Fire Department continues to evolve both because of political and socio-economic factors, as well as new advances in fire science and technology.

Engine and truck companies are currently being outfitted with laptop computers containing maps of city streets as well as diagrams of commercial buildings. Firefighter/paramedics that staff every Oakland engine company are able to utilize the latest advances in emergency medicine to save victims of trauma or cardiac arrest. Handheld thermal imaging cameras (TICs) are currently being placed on every Oakland truck company to better assist in locating, confining, and extinguishing fires. However, tried and true firefighting tools over 100 years old, such as the pick-headed axe, pike pole, and smoothbore nozzle, remain in the arsenal of today's Oakland firefighter. While all of these transformations have continued to take place, the mission of the OFD has always remained constant: to preserve the lives and property of the citizens of Oakland.

Today, Oakland is home to 400,000 people and is one of the most diverse cities in the world. Its modern downtown is dominated by shiny skyscrapers and older, more ornate mid-rise buildings, while North, East, and West Oakland contain a mix of residential, commercial, and industrial neighborhoods. (Courtesy of the Oakland Fire Department.)

Gone are the fire-alarm boxes that were found on almost every street in Oakland. Present-day dispatchers staff the Fire Dispatch Center (FDC) at Engine Company No. 1, Truck Company No. 1, and Battalion No. 2's quarters downtown and use a Computer Aided Dispatch (CAD) system to send companies to emergencies received on the 911 system. (Courtesy of the Oakland Fire Department.)

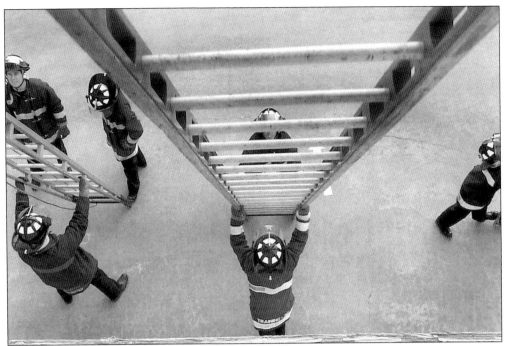

OFD recruits attend a rigorous 14-week training academy and learn all about the basics of firefighting, especially throwing ladders and pulling hose. When they graduate, these new kids are assigned to one of three battalions and begin to put their new training to the test. (Courtesy of the Oakland Fire Department.)

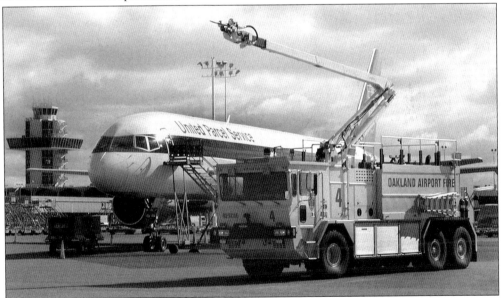

In 1998, the OFD began providing fire protection for the Oakland International Airport. Five Airport Rescue Firefighting (ARFF) vehicles and a command vehicle are housed at Engine No. 22's quarters, located just off the main runways. Rescue Company No. 4, pictured here, carries 3,000 gallons of water and 250 gallons of foam, and can reach speeds in excess of 60 mph. (Courtesy of the Oakland Fire Department.)

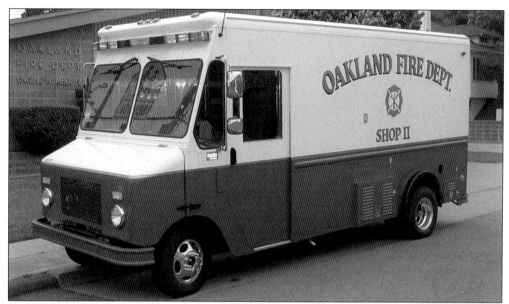

Shop II, a 2001 Grumman utility truck, is used by City of Oakland Heavy Equipment Mechanics as a mobile repair center. These mechanics staff the vehicle and are able to make light and medium-duty repairs on fire apparatus throughout the city. (Courtesy of the Oakland Fire Department.)

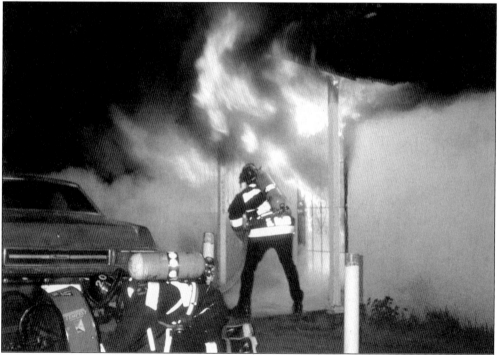

Firefighter Ken Cuneo of Engine Company No. 20 opens up a hose line on a well-involved fire in a single-family dwelling in East Oakland in 1995. Nicknamed "The Animal House," Engine Company No. 20, Truck Company No. 7, and Battalion No. 3 is currently the busiest firehouse in Oakland. Running a combined average of 6,000 calls per year, these three companies serve one of Oakland's poorest neighborhoods, the Elmhurst District. (Courtesy of Ralph Kurio.)

The Ebony Plaza Hotel, a vacant four-story building on Twenty-ninth Street and San Pablo Avenue, was set ablaze by an arsonist in 1995. The arsonist lit several fires on the top floor using gasoline. Flames spread rapidly to the attic, dooming the old hotel. Here, the crew of Truck Company No. 1 ascends their aerial ladder to the roof while an engine company works their way up the fire escape. (Courtesy of Bill Wittmer.)

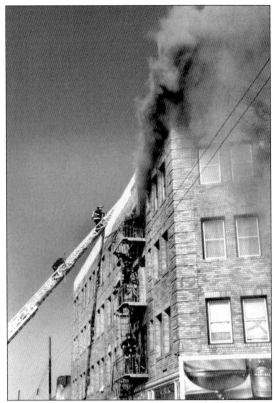

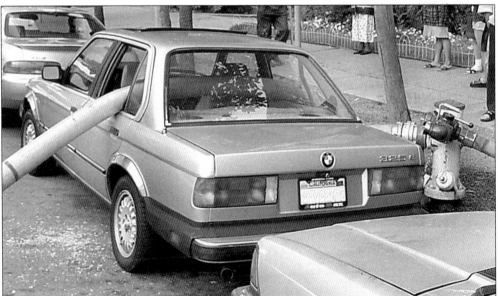

The owner of this BMW learned the hard way not to park in front of a fire hydrant in Oakland. Firefighters were forced to improvise when they encountered the illegally parked vehicle at the scene of a five-alarm apartment building fire at 1514 Jackson Street on September 24, 2000. To add insult to injury, the owner of the car was issued a parking ticket! (Courtesy of Danny Barlogio.)

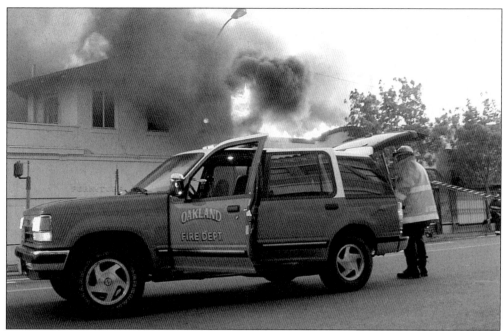

Companies of the 3rd and 4th Battalions fought a three-alarm fire that damaged five buildings on the corner of Foothill Boulevard and Seminary Avenue on May 2, 2001. An aggressive attack by firefighters prevented the entire block from being destroyed. (Courtesy of Danny Barlogio.)

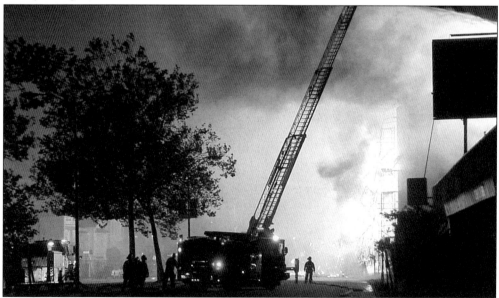

Battalion Chief Dennis Rainero radioed to Oakland's fire dispatch center, "Give me all you've got, and keep 'em coming," after he arrived on the scene of this "urban conflagration" on West Grand Avenue in the early morning hours of May 3, 2001. High winds carried embers from a large commercial building fire throughout a six-block area, starting fires in 14 Victorian-era homes. It took almost every company in Oakland and several more from neighboring fire departments to bring the blaze under control. (Courtesy of Danny Barlogio.)

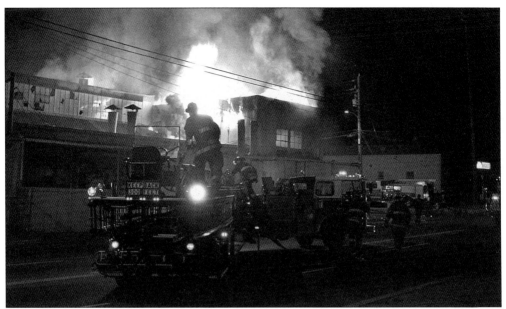

Flames break through the roof of an abandoned warehouse on the corner of San Leandro Boulevard and Forty-eighth Avenue in East Oakland in February 2004. Members of Truck Company No. 6 can be seen readying their "ladder pipe" for operation. A ladder pipe is a master stream device attached to the tip of an aerial ladder and can provide 1,000 gpm. Ladder pipes are mainly used on large, defensive fires where all companies operate on the exterior of the building. (Courtesy of Danny Barlogio.)

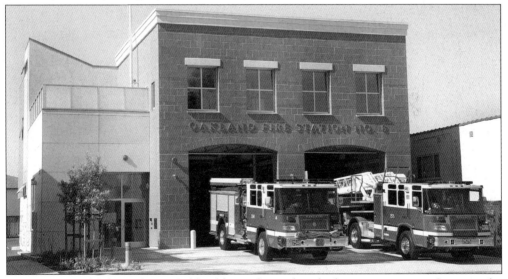

Many aspects of fighting fire in Oakland have changed in the last two centuries. Gone are the gallant fire horses and leather hoses used by the "smoke eaters" of yesteryear. Today's Oakland firefighters ride on modern fire apparatus and use SCBA's, lightweight synthetic hoses, and thermal-imaging cameras to fight fire. Pictured here are the new quarters for Engine Company No. 8 and Truck Company No. 5, completed in December 2002. Oakland's newest firehouse was designed to blend the OFD's historic past with the modern age of firefighting. (Courtesy of the Oakland Fire Department.)

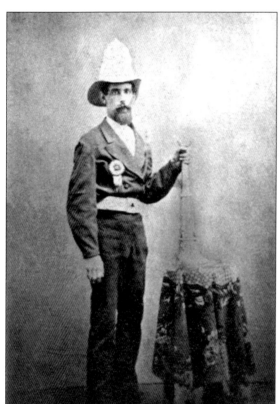

George Taylor
1872–1874

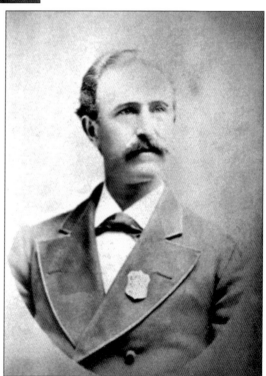

Matthew de la Montoya
1874–1877

Nine
SERVING WITH HONOR

The following pages carry the portraits of the many fire chiefs who have led the Oakland Fire Department. Many fire chiefs served only a short period of time, replaced like many other government appointees by a newly elected mayor. Others, such as venerable William Lutkey and James Sweeney, served tenures that lasted decades. Only the portraits of the OFD's first three fire chiefs (J.C. Halley, 1869; John Nalley 1869–1870; and Miles Doody 1870–1872) are missing.

James Hill
1878–1883

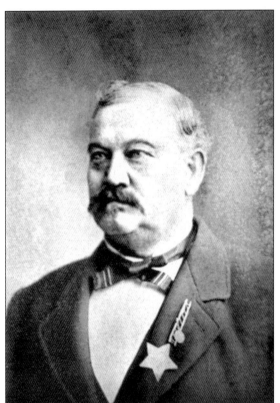

James Moffitt
1883–1889

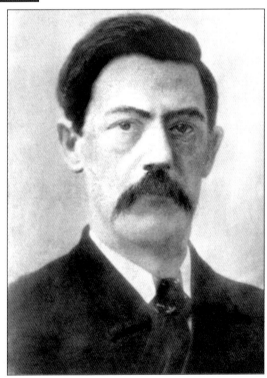

James F. Kennedy
1889–1893

Elburton B. Lawton
1893–1896

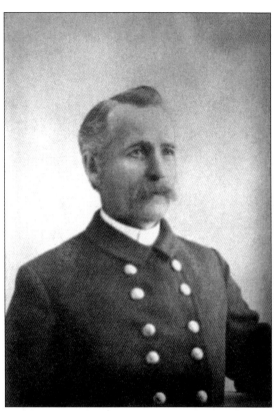

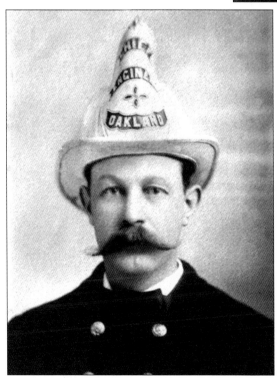

William H. Fair
1896–1898

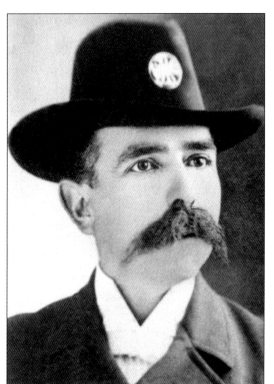

Nicolas A. Ball
1898–1915

Elliott Whitehead
1915–1921

Samuel H. Short
1921–1927

William G. Lutkey
1927–1947

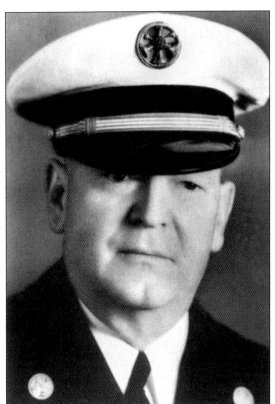

James H. Burke
1947–1955

James J. Sweeney Jr.
1955–1972

Stephen L. Menietti
1972–1976

William Moore
1976–1980

Samuel Golden
1981–1986

Goodwin Taylor
1986–1991

Walter Pierson (Interim Chief)
1980–1981

P. Lamont Ewell
1991–1996

John K. Baker
1996–1999

Gerald Simon
1999–2004

Danel Farrell (Interim Chief)
2004–

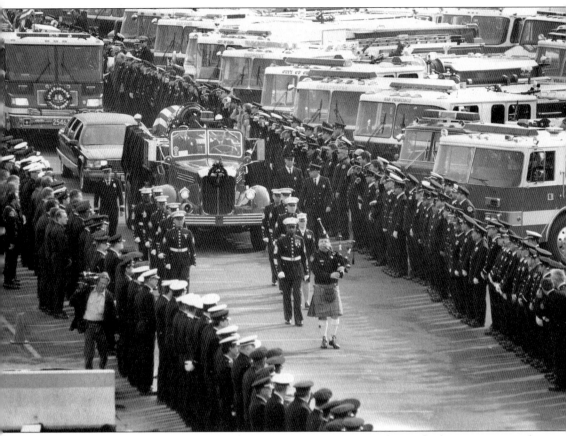

This was the funeral procession for Firefighter Tracy Toomey, who made the supreme sacrifice on January 10, 1999. His flag-draped casket was carried in the hose bed of a 1948 Mack fire engine. Thousands of firefighters and hundreds of fire engines throughout California came to pay their respects to the fallen hero. (Courtesy of the Oakland Fire Department.)

Line of Duty Deaths

The following 13 Oakland firefighters made the supreme sacrifice in the performance of their duties:

1903	Hoseman Frank Parker	Engine No. 3	Building collapse
1925	Hoseman Thomas Heelan	Engine No. 1	Fire engine struck by train
1940	Hoseman Dewey Records	Chemical No. 1	Building fire
1946	Capt. Joseph Pimentel	Engine No. 24	Fire engine struck tree
1947	Hoseman Louis Cetraro	Engine No. 3	Roof collapse
1957	Lt. Ralph Waalkes	Engine No. 32	Electrocuted
1968	Lt. John Carlyon	Engine No. 31	Brush fire at Mills College
1968	Hoseman Floyd DeMarca	Engine No. 31	Brush fire at Mills College
1968	Hoseman Terry Silveria	Engine No. 31	Brush fire at Mills College
1979	Lt. William Elliott	Truck No. 1	BART Trans-Bay Tube fire
1990	Firefighter Lance Peterson	Engine No. 4	Fell from fire engine
1991	Battalion Chief James Riley	Battalion No. 4	Struck by falling power pole
1999	Firefighter Tracy Toomey	Engine No. 12	Building collapse